"YOU ARE NOT ON THE GROUND, YOU ARE 3,000FT ABOVE IT, STRAPPED INTO A HARNESS THAT FITS MORE THAN SNUGLY AROUND YOUR LEGS AND WAIST AND IS TIGHTLY BOLTED TO THE UNDERSEATING OF A LONGRANGER HELICOPTER. THE DOOR TO YOUR LEFT, ABOUT TWICE THE SIZE YOU WOULD FIND ON THE AVERAGE CAR, HAS BEEN TAKEN OFF SO THAT YOU CAN LEAN OUT AS FAR AS NECESSARY."

"THE AIRBORNE MAN SEES THINGS THAT ARE HARD FOR THE PEOPLE ON THE GROUND TO COMPREHEND. HE BECOMES FAMILIAR WITH THESE THINGS. BECAUSE YOU'RE A LAYMAN, IF YOU HAVE AN INTENSE INTEREST IN THE VISION ASPECT OF THIS, YOU ACCUMULATE KNOWLEDGE THAT BEGINS TO FIT TOGETHER IN A BIGGER PATTERN. I HAVE A PLATFORM FOR OBSERVATION."

Aerial

The Art of Photography from the Sky

RotoVision

A RotoVision book

Published and distributed by RotoVision S.A.
Route Suisse 9
CH-1295 Mies
Switzerland

RotoVision SA,
Sales, Editorial & Production Office
Sheridan House, 112/116a Western Road
Hove, East Sussex BN3 1DD, UK

Tel: +44 (0)1273 72 72 68
Fax: +44 (0)1273 72 72 69
Email: sales@rotovision.com
Website: www.rotovision.com

10 9 8 7 6 5 4 3 2 1
ISBN 2-88046-727-6

Picture acknowledgements
Hulton Archive, pages 10, 11 and 13; Richard D. Statile/Hulton
Archive, page 12

Text by Adele McConnel and Jason Hawkes
Designed by Becky Willis (poddesign@btinternet.com)

Production and separations in Singapore by ProVision Pte. Ltd.
T: +656 334 7720
F: +656 334 7721

Aerial

The Art of Photography from the Sky

Jason Hawkes

Contents

Introduction: The high points

Imagine being in New York on a fall day; bustling Central Park turning all greens into russet browns, the crisp winds putting a bite into the air, the unmistakable Manhattan architecture all around you. Imagine it again with a slight difference. You are not on the ground, you are 3,000ft above it, strapped into a harness that fits more than snugly around your legs and waist, and is tightly bolted to the underseating of a Longranger helicopter. The door to your left, about twice the size you would find on the average car, has been taken off so that you can lean out as far as necessary. The whine of the jet engine, the rush of air through the door and the roar of rotor blades a few feet above your head fill your ears and ensure the usual sounds of New York City are entirely obliterated. Normal speech is impossible, so communication with the pilot is limited to shouting through headphones. And while you thought it was cold down there on the ground, at this height and without the protection of a door, the temperatures feel arctic.

A brief word with the pilot, via the headphones, and you start your descent directly over the Chrysler Building. Keeping up as much speed as possible for safety reasons, you rapidly lose height in a tight spiral turn. At about 60ft above the spire of the building the pilot quickly turns right out onto the Hudson River. This is the lowest he will allow, as at this height the river is the only safe place to land in the unlikely, but not unheard of event of engine failure. You stay over the river for the next few minutes to reload the film backs and get ready to repeat the approach. With the rubber eye cup pushed hard around your eye to try and stop it from watering, and your freezing hands trying to work the tiny buttons on your camera, you circle the location. The external battery pack is stuffed down your pants (the warmest, if most uncomfortable, place for it) with the battery cord plugged into your camera. You have to block all this out as you lean out of the helicopter as far as you can – but not too far. You must focus entirely on the images you can see through the camera viewfinder and concentrate on getting the best shots you possibly can. If you'll excuse the pun, this is the high point of being an aerial photographer.

→ **Chrysler Building, Manhattan, New York, USA**
I've shot Manhattan on quite a few occasions, mainly for advertising briefs, and it has always been fantastic fun. The heliports are dotted around the island on the Hudson River, although there is always debate about closing them down because of noise pollution. It only takes about a minute or two between take off and flying around the spires of incredible skyscrapers. This image was commissioned for an ad for Mitsubishi cars, and we spent four days searching for the exact image the art director was after. On one flight I took up a friend, a keen photographer. It was her first helicopter flight, and I think it may also have turned out to be her last. We were doing some fairly steep turns in order to look right down on top of the buildings. She was pretty terrified. We developed the film after every flight and the art director would say, "Just a little lower over the spire and we'll almost have it". I was shooting with a wide-angle lens on my medium-format camera to exaggerate the perspective of the building. In the end we got to within about 100ft of the spire when the pilot finally had enough.

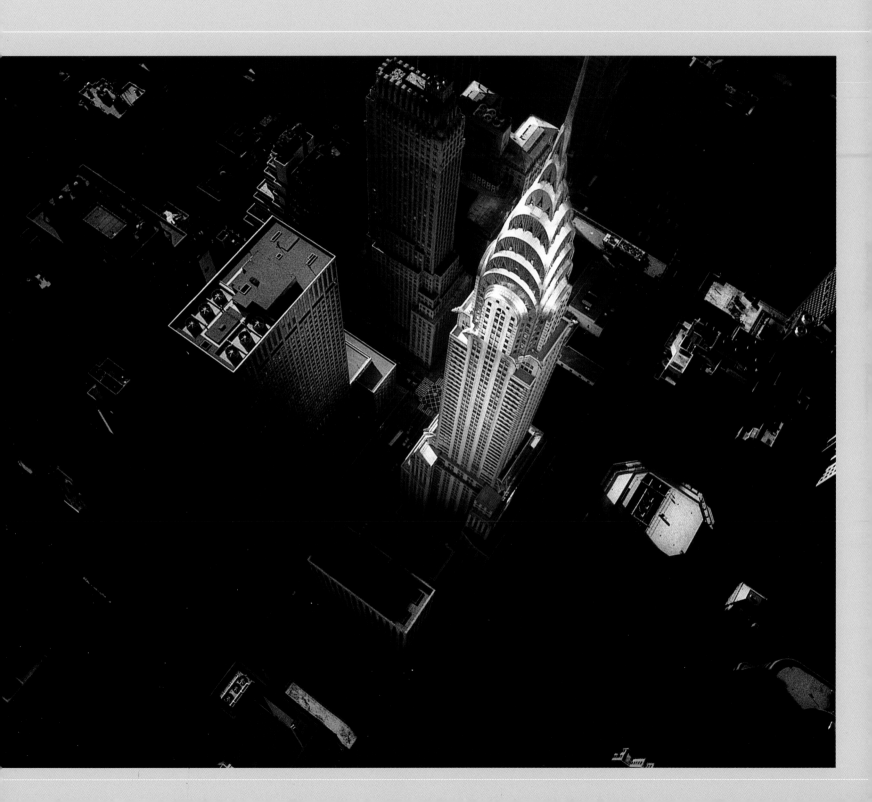

The history

The first documented aerial photographs were taken by the French balloonist and photographer Gaspard-Felix Tournachon, otherwise known as Nadar, in 1858. His idea was to use a basket on his balloon as a makeshift dark tent, and carry out wet-plate processing whilst in the air. The balloon he used was enormous. It was capable of carrying 50 men – a far cry from the tiny microlight that I started taking aerial photographs from. After trying this process for months without luck, he finally realized that the hydrogen gas used to fill the balloon had been escaping and ruining his chemicals. His initial goal was to map the whole of France with his new technique but unfortunately for him, his idea was met with ridicule. Despite this ignominious start, technology – and interest in the subject – had moved on to such an extent that by 1880 excellent images where being taken (notably by Paul Desmartes) using gelanto bromide plates that required an exposure of only 1/15th of a second.

Nadar may not have achieved his goal of making a land survey of his home country but he did capture the attention of the US army, who began to use his ideas quite extensively in the next few years. During the American Civil War President Lincoln authorized a Balloon Corps Unit but, unsurprisingly, in 1863 the unit was disbanded as the balloons had a tendency to draw enemy fire.

By the First World War the airplane had replaced the balloon, and reconnaissance flights were an everyday event. Photographic interpreters were employed by the military to study the aerial photographs, and to pinpoint the location of enemy bases.

Generally speaking, reconnaissance flights were a way of getting to know the contemporary landscape, but often they revealed facts about the past as well. As a result, aerial photography began to be pioneered in the 1920s at England's famous Cambridge University as a tool for archaeological investigation. Today it is an invaluable method for archaeologists. The main advantage of looking down on to the ground is to gain knowledge of spatial relationships – between a stream and ancient earth works, for example. Aerial photographs allow these features to be visualized and mapped, even when there is no visible trace from the ground. If you know what you are looking for, it is amazing what can be revealed by a single photograph. A dark hue of soil might indicate a former settlement or industrial site, and a lighter strip could be the gravel of a Roman road. Grass grows thicker and deeper on filled-in ditches, but paler and more yellow on the remains of buried walls. Aerial photography is incredibly sensitive to external stimuli such as the light, the season, or even ground cover, and the angle of observation (either vertical or oblique) makes a huge difference.

I saw my first aerial photograph as a child. My father bought a huge black-and-white print of our local village to use as a visual aid in his opposition to a building application. He managed to win that particular case, but in many ways it was a short-lived victory. Twenty years on, the village we lived in has been built up to such an extent that I doubt many people would recognize it as the same place.

How, too, things have changed in the acquisition of aerial images. My father had difficulty getting hold of his photograph, whereas today it is possible to find aerial views of most places in just a few minutes by searching online. Terraserver and Getmapping enable you to view images by keying in a city name or post code.

As for the future, well I think it's already here. Today companies specialising in satellite images supply aerial shots and, if they don't have the one you want, they can shoot it during their next orbit.

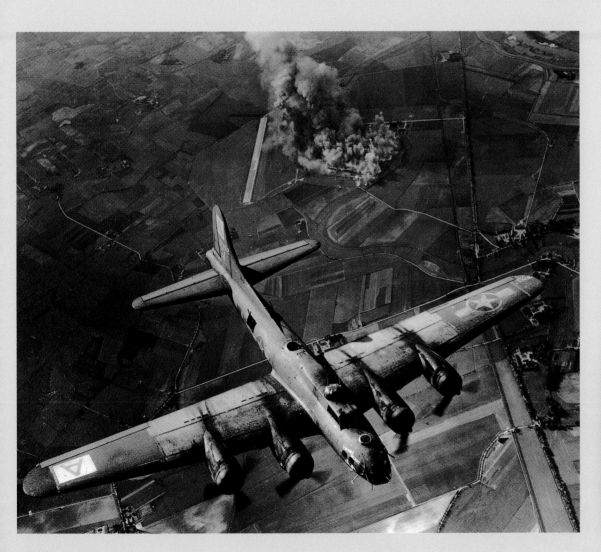

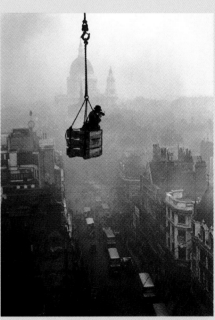

Photo reconnaissance
Mechanism of an externally mounted camera receives a final check before a mission.

↑ **B-17 bomber**
An aerial view of a B-17 bomber aircraft, in flight, with explosions on the ground from bombing. 'Virgins Delight' is written on the nose of the plane.

↑ **R J Salmon, daredevil photographer**
Fox photographer R J Salmon dangles in a crate suspended from a crane to take an aerial shot of Fleet Street, London. St. Paul's Cathedral may be seen in the misty background. This picture is taken from the 'Daily Telegraph' building.

Aerial art

And so, from the practicalities of aerial photography to the medium as an art form. Over the last 100 years, there has been much discussion on the topic, a lot of which has been negative but this view seems to be changing all the time.

In the early twentieth century, Edward Steichen was one of the most important figures in the history of photography, and a passionate advocate for photography as an art form. Along with Alfred Stieglitz, he led an aesthetic revolution that considered photography to be a medium appropriate for interpretation and expression, and not simply a documentary record of visual facts. Considering the strength of his viewpoint, it is interesting that this didn't extend to aerial photography. Steichen was of the opinion that, '... the average vertical print is upon first acquaintance as uninteresting and unimpressive a picture as can be imagined ... it badly represents nature from an angle we do not know.'

After his first-ever flight, Ernest Hemingway wrote, 'the ground began to flatten out beneath us. It looked cut into brown squares, yellow squares, green squares and big flat blotches of green where there was a forest. I began to understand cubist painting.' Whether he was being sarcastic or serious is a point of contention, but by pointing to the relationship he was at least recognizing that aerial photography might be considered a form of art.

More recently, William Garnett, the great aerial photographer, had the following to add to the debate. '... the airborne man sees things that are hard for the people on the ground to comprehend. He becomes very familiar with these things. Because you're a layman, if you have an intense interest in the vision aspect of this, you accumulate knowledge that suddenly begins to fit together in a bigger pattern that the land-based person does not see, does not have the opportunity to see. It's not that I'm unique in any way, it's that I have a platform for observation.'

During my career to date, my work has been both dismissed as too commercial and criticized for being too abstract. This naturally leads me to believe that the value of an image is in the eye of the beholder. In 1953, Irving Penn famously quipped that, 'Photographing a cake can be art.' Certainly his images of cigarette and cigar butts were a primary influence on me when I was starting out as an independent photographer.

In the twenty-first century, 'art' arguably encompasses a wider definition than ever before. Today I think that it is easier to 'read' aerial photographs whether they are shot for aesthetic or practical reasons. We are now well-acquainted with the view from an airplane window and satellite images. If he were alive today perhaps Steichen would change his viewpoint.

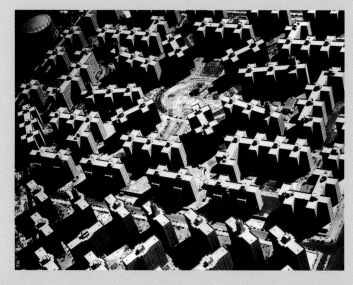

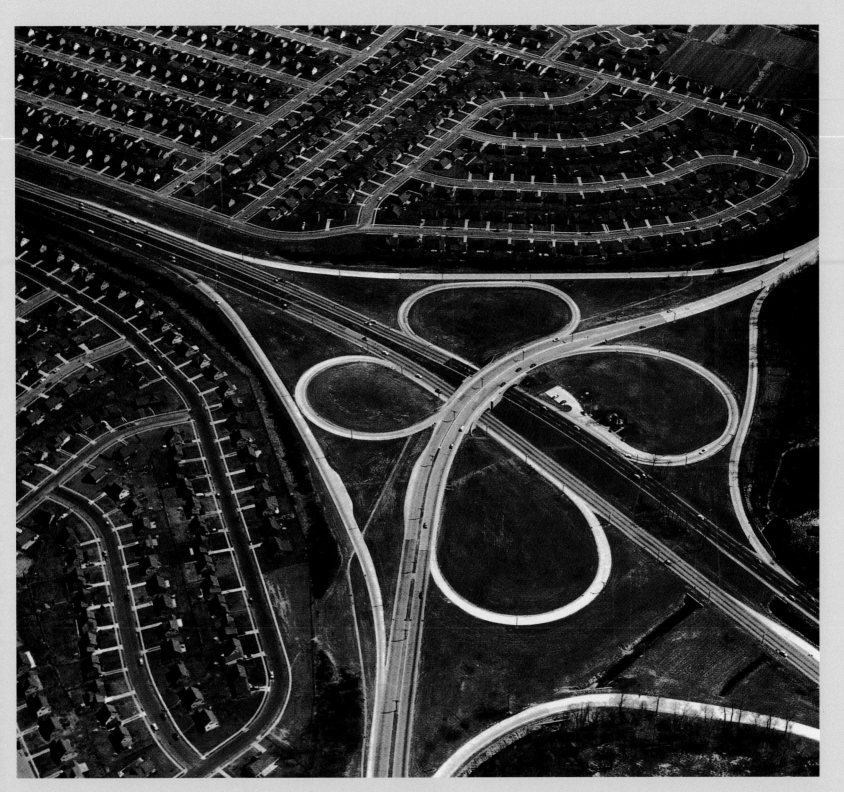

Streets above

An aerial view of Stuyvesant Town housing projects, built for middle-income families, on the east side of Manhattan between 14th and 23rd streets, New York City.

↑ **Road network**

An aerial view of car ramps on a freeway, and track housing.

A social document

Flying over your own home, the city you live in, or somewhere you have been on holiday is a fascinating thing to do. You can stare into your neighbor's garden and are guaranteed to see something you did not know was there. Many people I know have an aerial view of their house hanging on their wall, and from a personal perspective I can see why. While editing the images for this book I came across an aerial photograph, taken seven years ago, of the house where I live. In the garden is my wife, Adele, looking up at me (although at the time she was my girlfriend rather than my wife, and she isn't holding our daughter Anouska as she might do now because she had not yet been born).

Aerial images are social documents of our lives. I read a very poignant story a couple of years ago written by a woman who had been brought up on a farm in Devon, southwest England. She had led an idyllic childhood, living a carefree existence with her brothers and sisters, enjoying the freedom to roam at will in the neighboring countryside. The only remaining tangible reminder of her childhood was a battered old aerial print of her parents' farm, which had long since disappeared beneath a new town. She said that while for other people it was just an old, tattered photograph, it was, for her, the only connection to her youth.

Nonetheless, as a photographer I am most interested in locations and objects that make a strong composition or striking visual impact. The images selected for other books I have worked on have concentrated on specific regions, and the pictures in them necessarily provide a greater social context by documenting the landscape of the area. In contrast, the photographs in this book have been chosen largely for their visual content, the way they pick out the colors, patterns, textures – the fabric – of the landscape, and they constitute some of my favorite photographs taken during my career thus far.

↱ **Medellin, Colombia**
Last year I was contacted by Rebecca Greenall who works for the British Council in Colombia with an idea for an exhibition of my work of aerial views of Britain. I jumped at the chance of visiting Colombia and the exhibition was held at the Archaeological Museum in Medellin. While there, I took the opportunity of flying with a local pilot in his Cessna light aircraft. Beautiful mountains surround the city with fantastic plains above them. Within the first few seconds of taking off the tiny plane was tossed around by the wind turbulence coming off the mountains and we continued like this for about another hour before eventually climbing above the mountains to clear air. The pilot, who I guess was used to this type of turbulence, seemed completely unperturbed by this, but I must confess to feeling a little uneasy having never flown with him before.

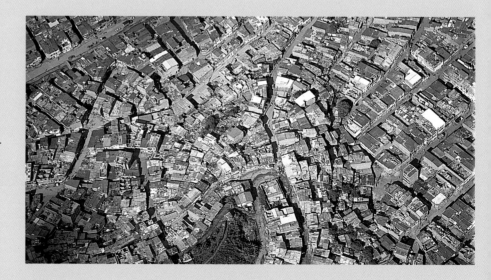

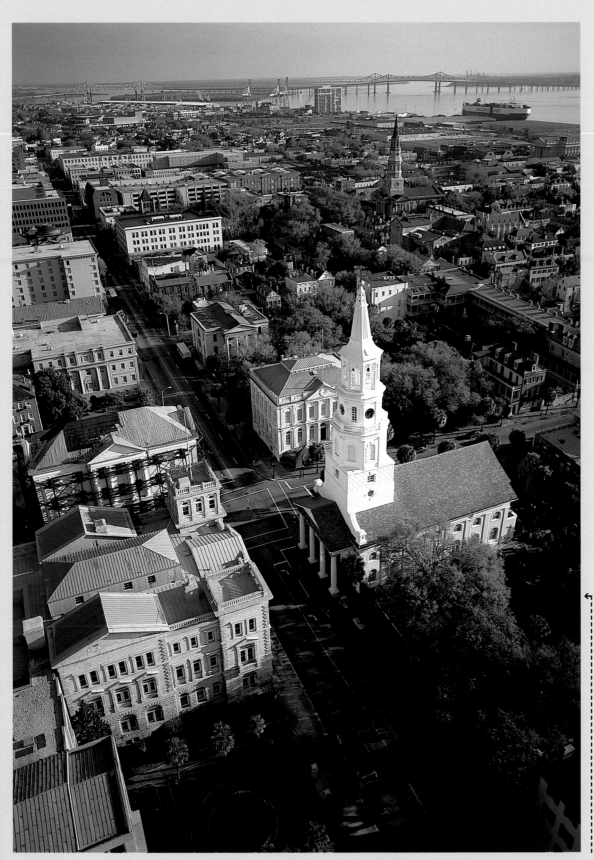

Charleston, South Carolina, USA

I can't remember exactly what time it was that I took this image, although if you look carefully at the clock you might be able to see. I remember however that it was Sunday morning, and most of the residents in Charleston might well have been in bed or at least having breakfast, and probably did not want to be disturbed by a Hughes 300 circling overhead, especially at this height. To do this in the UK would have been a serious error of judgement; upon landing we would have been inundated by irate callers upset by the noise. I can only think that in the Carolinas they have a more laid-back attitude to such things. Perhaps it's the heat. The pilot who flew me around South Carolina had started out as a pilot at the tender age of 21 in the Vietnam war, and had spent something in the region of 15,000 hours in the air. He told me stories that would make your hair stand on end.

The ups and downs of the early days

So, how did I get into aerial photography? By accident rather than design. In 1988, when I was 21, I had just finished a three-year OND in London and had landed my first job. Throughout my Art Design foundation course and subsequent OND, I had assumed I would become a still-life advertising photographer. College teaches you that the only route to achieving this aim is to assist for two to three years, and so I started working with a variety of photographers at a studio in Covent Garden, London. As anyone who has ever assisted will know, a large part of my day involved loading film and fetching sandwiches and tea for the photographer, models, and crew. However, the subject matter each day was different; from fashion to still life to food shots, and I can honestly say that I thought I had found my calling when I was required to assist on a lingerie shoot involving around 20 or more scantily dressed girls.

One weekend, a couple of friends and I came across an article on microlights in an extreme sports magazine. We thought they looked like fun, and for no reason other than for something to do, booked a trial lesson, and the next afternoon found ourselves in a field in Kent, southeast England. To begin with, we weren't even sure if it was the right field. However, a low buzzing, accompanied by a little black dot, gradually evolved into a louder buzzing over the trees and a microlight landed a few metres away. After a safety briefing from instructor Rod Clarke, I was soon looking out over the patchwork fields of Kent.

The microlight we went flying in that day was a two-stroke petrol engine called a Hybrid R. The R stands for Raven, so-named because the body is black. These microlights have a top speed of around 45mph and there is just enough room to fit two passengers. Although they are capable of reaching heights of 12,000ft, they rarely go above 2,000ft. That first day, our maximum height was 1,500ft. Flying in a microlight feels very different to flying in a helicopter or small plane. Some people say it is like sitting in a deckchair, with just a small canvas seat separating you from the ground below. I remember thinking it was like flying on a motorbike, but mainly that I really should have my camera with me.

Exhilarated from the flight, my friends and I chattered excitedly about how great it would be to earn pilot licenses and to fly our own microlight. In fact, we dreamt of buying a microlight exactly like the one we had just been flying in; the sleek, black lines of the machine obviously igniting some deeply buried James Bond-esque fantasy. Of course, we couldn't afford it. Second-hand microlights cost several thousand dollars – slightly out of reach for someone who, at the time, was earning a pittance. However, the idea stayed in my mind over the next few weeks and I was determined to make owning a microlight more than just a dream.

The idea literally came to me one night. It was clear we would need a loan if we were to buy a microlight. A business loan offered the best rate and so I decided to write a business plan for an aerial photography company. A bank approved the loan and we also joined a Government-funded Small Business Enterprise Scheme. In total we raised enough money to buy a microlight and for three people to get their pilot's license. We were on our way!

There was just one hitch. There are many different types of pilot's license, both private and commercial. For a microlight, a private license involves about 25 hours of flying, half under supervision and half solo, plus ground school. It may not sound like many hours, but because you can only train in very low winds, in Britain it can take months. By contrast, a commercial license

demands hundreds of flying hours but such a license is unavailable for group D aircraft, including microlights. A private license cannot be used for a commercial venture, which meant that I couldn't directly sell any pictures that I took from flying in our microlight. I had given up assisting and was living on a small enterprise allowance. For the first year or so times were lean but once the first of us earned his license I was able to build up a portfolio of aerial shots. It took about a year before I felt my work was strong enough to show to other people.

My first chance at getting some work in the public eye was via the now defunct *Photography* magazine, published in Britain. I had avidly read the magazine since my interest in photography began, and I had nothing to lose by calling the editor to arrange a meeting. Fortunately for me he showed great enthusiasm for my portfolio and immediately agreed to publish an eight-page spread of my photographs. In a roundabout way this led to my first book, *London from the Air*, which was commissioned by Random House. Today this book is in its third edition and has sold almost 250,000 copies.

London, England
Flying over London is a rare pleasure. You get a great view of the whole capital, while at the same time gaining insight into places you might otherwise not know exist.

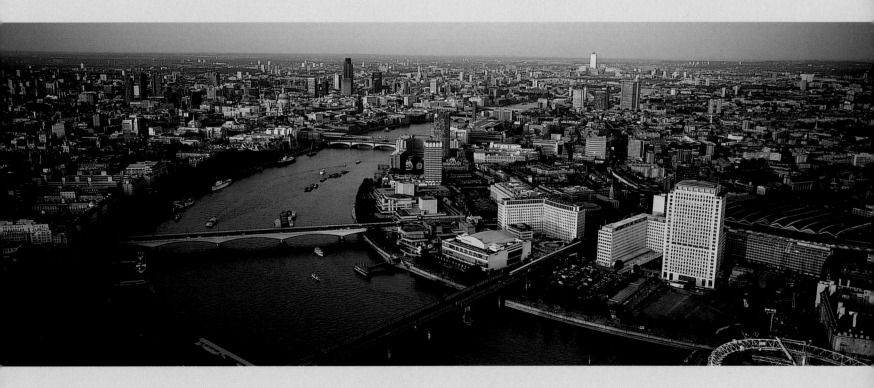

Taking flight

Generally speaking, the majority of my work can be divided into four distinct categories: producing books, one-off jobs for advertising or design clients, providing images for stock libraries such as Corbis and Getty, and managing my own specialist aerial photographic library.

When I started out, the big money was in high-profile advertising campaigns and these were invariably supported by substantial budgets. This isn't really the case any more. In recent years, budgets have been cut. Art directors are now more likely to check out the less expensive option of buying a stock shot before approaching a photographer to start the process from scratch. While the results can be more than worth it, the medium of aerial photography clearly has various costs attached to it. An advertising budget would need to cover research for up to two days as well as enough 'air time' to achieve the desired result.

Because of this, stock libraries are gaining a larger and larger share of the market and now that so many are trading with fantastic online sites, new commissions can be hard to come by. Photographers such as myself who have niche market libraries must work hard to constantly update their own websites in order to compete with the market leaders. Keyword searches and personal lightbox facilities are now standard features that all library websites require to be taken seriously.

However, with new commissions there can be no compromise. The client wants something unique. For the aerial photographer, the challenge is to listen intently to the brief and then carefully plan and prepare the shot before the flight – you can't rely on something just catching your eye once you are in the air.

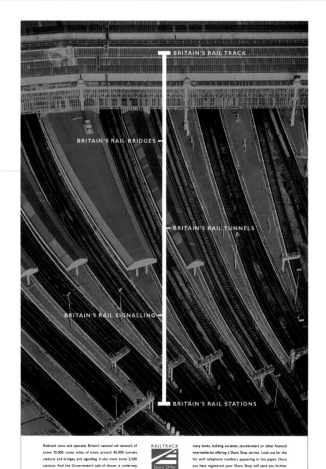

← **Railtrack**
Agency: WCRS
When Railtrack (the UK's national railway company) was being privatized, they called on advertising agency WCRS to provide all the TV and press campaigns. Art director Tim Robertson was asked to produce the concept for the campaign, and decided to use abstract aerial images. He called me to work on the stills. He needed shots of track, stations, bridges, and tunnels, and asked me to come up with some suitable locations. I had flown over most of Britain, and put together a list of places. The list was honed down to ten, and then left to me to shoot the images. The film crew who were working on a TV ad along a similar theme had, I later guessed, little idea of how these places looked from the air, so I spoke to the agency and later sent them a list. The work was all shot on black and white, and color was added later as you see it here.

Normally, the starting point for advertising work is to meet with an art director who will provide a rough layout from which to work. Last year I was commissioned to work on a series of ads for BP. The first concept needed a perfectly straight set of crossroads together with the company colors (yellow and green) in one of the four adjoining fields. Crossroads can be looked up on a map – the colors of the adjoining fields are a bit trickier. Having identified potential locations, I spent quite a few hours flying around the countryside shooting various sites and adding them onto a digital map using a handheld GPS (Global Positioning System) unit. Eventually, I found the perfect location: a crossroads with glorious yellow and green fields. We re-shot it in perfect sunlight, and added a truck that we hired to complete the shoot a week later. Both the client and agency were pleased with the results.

Books are a very different prospect and it can sometimes take as long to sort out the contracts as it does to produce the book. Books allow a much greater freedom in terms of photography. I will either approach an editor with an idea, or vice versa, and then spend a few weeks preparing a shot list of proposed subjects. Once a budget has been agreed and the sites plotted onto maps, the fun part starts.

I usually talk to the pilot every evening when shooting for a book to plan the next day's shoot. The weather is the greatest saboteur of the best-laid flying plans. Notoriously difficult to predict in Britain, it is not only the cloud base that needs to be considered for aerial photography, but also the wind and visibility. A case in point is a shoot in Scotland a few years ago.

There was not a cloud in the sky for our morning take-off; visibility was excellent. Scotland was spread out below me and I was looking forward to a full day's flying. Within an hour, ominous rain clouds were building up around us and we decided to head back. We dropped lower and lower in an attempt to dodge them, using the VFR (Visual Flight Rules) as guidance. However, the clouds were obscuring our vision so badly that we soon realized we were not going to be able to return to the hotel garden and resigned ourselves to landing wherever we could. In the event, this turned out to be a deserted moor. The rain poured down around us as we did the only thing we could: sit and wait for it to stop. By mid-afternoon – several hours after the pilot and I had run out of things to talk about – the clouds had sufficiently dispersed to enable us take off again. Sitting in a helicopter in the pouring rain without food and dwindling conversation isn't much fun, but it is far safer to be on the ground in adverse weather conditions than to be battling it out in the skies.

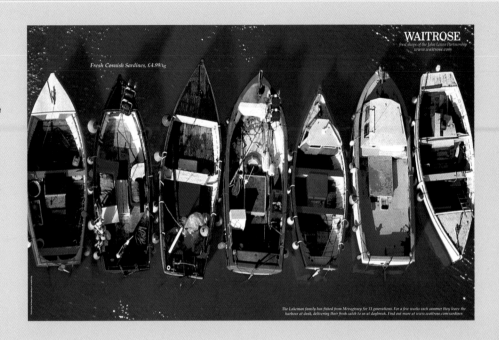

Fresh Cornish Sardines, £4.99/kg

WAITROSE
food shops of the John Lewis Partnership
www.waitrose.com

The Lakeman family has fished from Mevagissey for 15 generations. For a few weeks each summer they leave the harbour at dusk, delivering their fresh catch to us at daybreak. Find out more at www.waitrose.com/sardines

↑ **Waitrose**
Agency: Howell Henry
Art director Chris Walker was looking for an image for an ad. He wanted a shot of some fishing trawlers, so I emailed a series of jpegs to him. He picked a shot and presented it to his client. A couple of months later he called to say that the client wanted us to shoot a similar image in a small harbor in Cornwall on the southwestern tip of England. The agency arranged a week when all the trawlers were in the harbor but, in the event, it rained every day. I had arranged for the party to fly down to Cornwall from a heliport outside London, but we were forced to book one close to the site, drive down and stay overnight to wait for clear skies. The trawlers turned out to be fishing boats, much smaller than we had anticipated. With persuasion, the pilot went down extremely low over the harbor. We shot the ad from 150ft above the harbor as I stood on the edge of the helicopter skids and leant out to get the right shot.

Technicalities

With three years' study of studio photography behind me, I could go into great detail about all the techniques you are taught you might need. Similarly, there is a plethora of diverse techniques used in aerial mapping: sensitrometric evaluation, spectral characteristics, geometric accuracy, and the stereoscopic model, to name but a few.

By contrast, the way I like to shoot is relatively simple. I work more like a landscape photographer than I do an aerial mapper, but using a helicopter instead of a Benbo tripod.

I usually shoot on a medium-format camera, either a Pentax 645 or Hasselblad. I also use a Fuji 6x17 panoramic, or more recently, a Hasselblad Xpan, which is a 35mm panoramic-format camera. My film of choice is Velvia, usually in 220 format. Medium-format film size is about two-and-a-half times that of 35mm, and requires less enlargement, resulting in sharper, higher-quality pictures. The film is available in rolls of 120 and 220. I keep digital copies of a lot of my work, but have yet to make the leap to shooting digitally. It's a psychological barrier really, but, without doubt, in the next few years I'll be leaving film behind.

Focusing: well, there is no real need to. You'll never be close enough to a subject to warrant it so I tape up my lenses to infinity. Unless you use a gyroscopic mount you need to shoot at 1/1000th of a second, which sometimes means pushing Velvia one stop, from 50 to 100ASA. Lens-wise, I use anything I have to, from fish eyes through to wide angles and small telephotos.

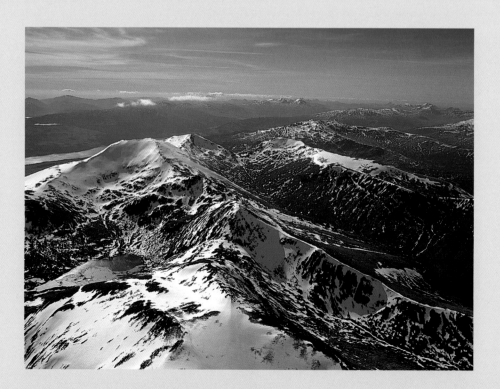

↱ Grampian mountain range, Scotland
We were 5,000ft above the mountains shooting this, and it was pretty cold. I was commissioned to take a series of images around southern Scotland for Grouse whisky who needed them for a new multimedia centre and museum. They were to be used in a visual presentation in which viewers would be taken on a virtual flight across Scotland. Most of the images needed to be in overlapping strips looking directly ahead.

I had tried to source a twin-engined light aircraft which can house a computer-controlled mapping camera in the fuselage. The only aircraft I sourced was too much for my budget. By luck I found a Longranger helicopter equipped with skis perfect for landing on snow.

Fastening my cameras to my harness and my harness to the aircraft I lay on the floor and held the camera as far underneath the aircraft as possible. Having gauged the exposure, and informed of the distance measurements, I took the images without being able to look through the viewfinder. The freezing conditions meant that I was taking longer to change each film, and I was glad to get back into the aircraft. Luckily, the images (and the presentation) came out great.

Shooting

I plan everything in as much detail as possible in advance, but more often than not all plans are revised in the morning once I've checked out the weather. Depending on the type of helicopter I'm shooting from we'll either take off the door beforehand or, in the case of some twin squirrels, just slide it open once in flight. After the cameras are loaded and I'm securely strapped into a harness, it's time to set off for a few hours' photography.

Switching from one air traffic controller to another, and always keeping an eye out for other aircraft, we'll set off from one location and head to the next. Without doubt, for me the most interesting part of being airborne is the unexpected patterns and shapes that materialize out of the most mundane subjects. Run-down housing estates, garbage tips, factories, and parking lots all produce original images from this angle.

Once we find a place that I'm looking for, or a location I think will make a good image, I let the pilot know via our headphones. We'll get into position beforehand, either climbing or descending, so that by the time we are overhead we are at a good shooting height for that particular subject. Depending on what angle I want we'll either make a few gentle orbits around the location or put the helicopter right on its side in a tight turn so I can get a shot looking vertically down. This type of flying maneuver can put your stomach in your mouth and is even more nauseating if you are looking through a viewfinder. My tip is to look at the horizon as much as possible when you are reloading the camera backs. It's worked for me so far; I haven't been sick in the back of a helicopter yet, but I'm sure the time will come!

I number up my films (usually Velvia 220) as soon as they are out of my camera and make as many notes as possible about each one, while also adding waypoints onto a handheld GPS unit. Back at the office I'll check through each film, download the waypoints onto some mapping software on my PC, and type up any accompanying notes. My penmanship is terrible at the best of times, and factoring in the vibration from a helicopter together with the wind gushing through the door, I'm more than happy to have the back-up of the GPS.

← **Portrait of the photographer**
This is an unusual moment: a photograph that is taken of me rather than by me – or perhaps it is both! This is relatively hazard-free compared to some of the other stunts I've had to do to line up a shot.

Life as a photographer

Being a photographer is a true vocation for me. I enjoy taking photographs, and I think getting paid for something I enjoy so much is a pretty good state of affairs. No two days are the same and every job presents a fresh set of challenges. Furthermore, seeing your work in a magazine, winning an award, or having your name on the front cover of a book all bring with them a great sense of achievement. Like any job, it's good to receive recognition for something you have put a lot of time and effort into, no matter how large or small.

Working freelance, as every photographer I know does, gives you plenty of freedom but also brings its own set of ties. Every time you complete a job you are essentially unemployed again until the next one comes along, and while you might be in the frame for ten jobs a week, only a fraction of them will actually come off. On a bad day, it feels like I spend more time looking for work than taking photographs.

Because of this unpredicability, it becomes ever more important to market yourself correctly to those who are in a position to employ you. Generally, I market myself by direct mail. Three times a year I brace myself, sit down and send out between 2,000 and 10,000 postcards. The intended recipients are art buyers and directors at all the large advertising and design agencies, and picture editors and buyers at magazines. I also send mailers to book publishers and any large corporations that have in-house design teams. It's a laborious task and not one I look forward to, but it's a necessity. It's important to remind these people about what I do and update them with any new pictures I have taken.

There are professional associations set up that can help you establish yourself as a photographer. In the UK, BAPLA (www.bapla.org) is a good starting point. They have links to hundreds of photographic libraries from extensive portals where you can search through millions of images, to tiny, very specific libraries that might sell images of one subject: food, celebrities, or aerial photography.

I'm also a member of the Association of Photographers in London (http://www.the-aop.org). They provide a multitude of services, for example: helping to find assistant photographers placements, leading workshops on such diverse subjects as putting together a portfolio, new developments in digital imaging, and marketing yourself as a photographer. Every year they also hold a prestigious awards ceremony in London. The association was instrumental in changing copyright laws in Europe to protect photographers' rights, and can help out with any queries that you might have on the subject. It's certainly worth becoming a member and lending them your support.

I have come to the conclusion that it's best to try and do a little of everything in terms of marketing yourself, and also to be as creative as my budget allows. A couple of years back I sent a package of five of my aerial photographic books to two hundred of the top advertising agencies in London. It was an expensive exercise and it did not achieve immediate results. On the other hand, every so often I get calls from people wanting to use images from the books, so perhaps it worked in the long term.

→ **The photographer (right) and pilot Ian Evans next to a 'twin squirrel' helicopter**

I also take out adverts in directories such as *Creative Handbook*, *Black Book,* and *Contact*. These books are paid for by the advertising and space is expensive. Costs to place a full-page ad can be a couple of thousand dollars. However, more than ten thousand books are sent out free to buyers of photography and, whereas direct mail is in danger of going directly into the trash, these books act as reference guides. Buyers keep these books on their desks and dip into them throughout the year.

A very famous advertising guru once said that he knew half his advertising worked, he just wasn't sure which half. I know how he feels and I think it's a problem for any photographer, aspiring or established. Furthermore, it's one of those things that is impossible to second-guess. Some photographers swear by sending out posters of their work. But I have spoken to plenty of designers who advise not to bother with the expense as they don't have room to keep them in their office anyway, and more than likely it will be thrown away before it's even opened. Given the pros and cons, for me direct mail has proved to be one of the most effective ways to communicate with potential clients.

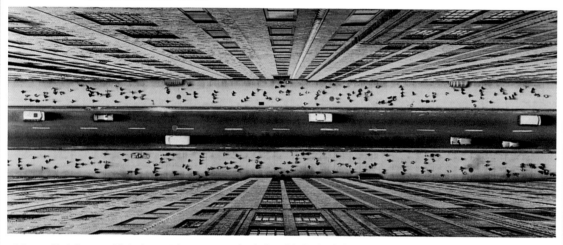

TO DISCOVER HOW DULL LIFE COULD BE.
SIMPLY JOIN THE DOTS.

You're young, confident, intelligent and ambitious. You have your whole life in front of you.

So why do you think the usual sort of pin-stripe job will suit you?

Could the excitement of a successful business transaction ever compare to the thrill of completing a successful combat exercise? Which would you really find

more challenging: playing a part in the defence of your country, or taking part in a company's audit?

You don't have to spend the rest of your life shuffling from home to the office and back.

You could find yourself co-ordinating Tornados on a sortie. Or you could be flying over the Atlantic aboard a Nimrod

reconnaissance aircraft, searching for a submarine. And all before your twenty-third birthday.

It isn't easy to get a commission in the Royal Air Force; we select all of our Officers with meticulous care.

No matter which of the eighteen Officer branches you'd like to join, your role will be essential. But while we'll be

looking for evidence of intelligence, you don't necessarily need a degree.

What you do need is a high degree of maturity and determination. And the confidence necessary to put your thoughts into action.

If we think you've got what it takes, we'll train you to do the rest.

Then, once you've completed your

training, you need never stop broadening your horizons.

New postings every couple of years will provide you with the opportunity to see all four corners of the earth.

A little more than your pin-striped counterparts will be able to manage with their annual fortnights in the sun.

It's up to you. Join the masses in the

City, or rise above it all by phoning 0345 300 100 or completing the coupon below.

ROYAL AIR FORCE
—OFFICER—

From time to time, a journalist will do an article about my work. Last year I was nothing short of delighted to discover that *Creative Review* wanted to run a double-page spread of my work and use an additional photograph for the back cover. It's an extremely prestigious magazine and everyone in the advertising and design industries reads it, so I sat back, put my feet up, and waited for the phone to start ringing. The day that issue came out, nothing happened. In fact, the phone didn't ring once as a direct result of that article. However, I get calls now and people mention they have seen it so it obviously attracted attention. On another occasion I had a tiny piece written about me in a free newspaper and, almost immediately, got an enormous number of follow-up calls as a result. You just never can tell.

Royal Air Force
Agency: JWT
This is really a pretty old image but I thought I would include it as I still think it works quite well. It was one of the first advertising briefs I ever worked on. The art director was Nick Wooton, and I was given a layout from him and asked if I could reproduce it. Without really thinking through the logistics I said yes and then went back to my office with the layout to work out how I could. I called a couple of pilots in New York and chatted with them about my brief. I really needed to get down pretty much between the skyscrapers to achieve the shot. We knew there would have to be a fair amount of post-production to clean up the image but we needed the basic shot pretty much as you see it here to work with.

A week later and I was off to Manhattan for the shoot. I had booked in a couple of days' flying in either a jetranger single-engined helicopter, or if we needed it, a more expensive twin squirrel helicopter. Now in order to produce the image, I had decided to shoot on a Fuji 6x17 panoramic camera with the widest lens available to get that exaggerated perspective Nick needed for the ad. A couple of hours flying around Manhattan and I was beginning to think I might have bitten off more than I could chew. Some of the images were beginning to work but I really wasn't getting what was needed. Another approach had to be thought of. After much staring at the buildings and even breaking onto the odd rooftop I hit upon the idea of shooting the road from a helicopter and the buildings from street level looking up to the sky. I wandered around Manhattan for a couple of days until eventually I found a building long and high enough. I shot plenty of film of it and later we cropped it down and turned it upside down, stripped in the road instead of the sky and then mirrored the building to make up the other side. It really could not have looked more like the original brief. The ad was put up for the D&AD awards as soon as we made it back to London and I was pleased to see it took an award and appeared in the book.

Selling library images online

Since setting up my own library, I am already on the fourth redesign of my website (www.jasonhawkes.com). Technologically, things change with extreme speed and to be credible in the market today you have to keep up. First impressions count, and I don't want potential clients, used to speed-efficient websites, to have to plod laboriously around mine. I have around 5,000 images online, which represents only a very small percentage of the images I have available. Clients can search for images by pre-defined search terms or by using a regular free search box. Once registered you can create your own lightbox of images chosen from anywhere on the site. There are links set up that allow you to buy my books online, or even to chat in an online forum about photography issues.

I am a member of Stone (www.gettyone.com) and Corbis (www.corbis.com). Both are huge online image portals with millions of photographs to view, purchase and download. In a few years I imagine even small libraries such as mine will have facilities for downloading high-resolution versions of images via rights-protected servers.

Essentially, libraries work as follows: assuming a photographer has not signed away their copyright, their archive can be sold for any usage. This might be editorial, for example in magazines or books, above-the-line advertising in the press, online or posters, or below-the-line in brochures and leaflets. There are thousands of libraries selling images which cover every conceivable subject. Usage rates vary not by the photograph but by the end use of the image. You could therefore sell the same image twice in one day, firstly, for example, to a French book publisher for 150 Euros, and additionally to an ad agency for a series of press adverts in the UK for a few thousand pounds. They buy a license to *use* the image rather than the image itself or the copyright of the image. The sales are usually rights protected, i.e. you cannot sell the same or similar image to another client for the same kind of usage. The last thing an agency wants is to have two adverts running in the same magazine using the same image for competing brands.

↱ **Stonehenge**
One of the most photographed places in England, I have shot Stonehenge more times than I care to remember, from heights of 30ft to 3,000ft, for everything from books to postcards and calendars. This is a fairly tight crop of the monument but greater heights show the ley line on which Stonehenge is allegedly situated. Bearing in mind that visitors to Stonehenge are no longer allowed to wander at leisure about the stones, an aerial photograph gives better access to the site.

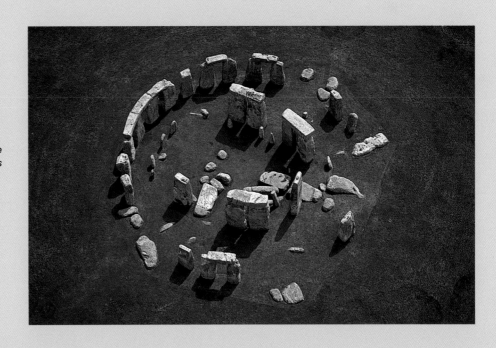

Showcase

It's all about perspective

Grand Prismatic Hot Spring, USA

I was commissioned by McCann Erickson, an agency in London, to go and shoot this lake for a pan-European press campaign. I had heard about how stunning the lake was meant to be, but I assumed that these reports were probably slightly exaggerated. So I called up a seasoned pilot who flew in the area around Yellowstone, someone I knew wasn't given to overstatement, and asked his opinion. 'You could lose your soul in the intensity of the colors,' was his reply.

A week later I was flying across the barren landscapes of Yellowstone, dodging snow flurries. It was just the beginning of the ski season and it was uncomfortably cold in the helicopter. We hopped over the top of a small mountain range and suddenly, there in the distance, was the most incredible explosion of color I have ever seen. It was a truly awe-inspiring 'take your breath away' moment. The different shades of blue that make the lake so visually arresting are a result of cyanobacteria, which grows faster at the edge of the water where the temperature is lower, hence the differentiation in color. The sheer vibrancy of the colors looked as if the lake had been lit from beneath by a giant lightbox. We flew around it for about 40 minutes, shooting as much film as I could in the time, but, if truth be told, one could hardly take a bad image of such a spectacular location.

Field fire

This doesn't look like burning stubble, but something more serious. In the UK, after harvesting, crop farmers used to burn out the stubble from the ground before plowing up the field. This routine has mostly died out now because of complaints about the smoke from neighbors, and environmental concerns.

From above, smoke is always a good indicator of wind direction and speed, and I know of quite a few microlight pilots who always keep an eye open in case of engine failure so that they can judge the best direction to make a forced landing as speedily as possible.

The colors of rural landscapes change rapidly through the seasons, and it seems to me even more evident from above than it is from the ground – here, the gold of the stubble gives way to blackened earth.

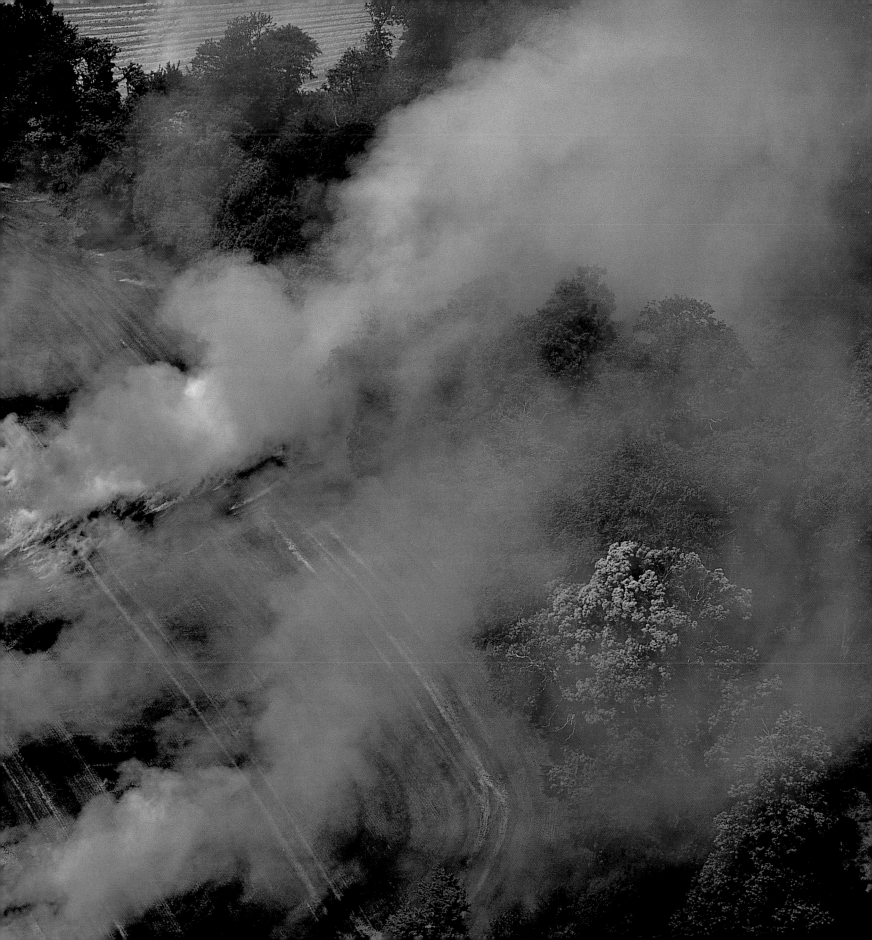

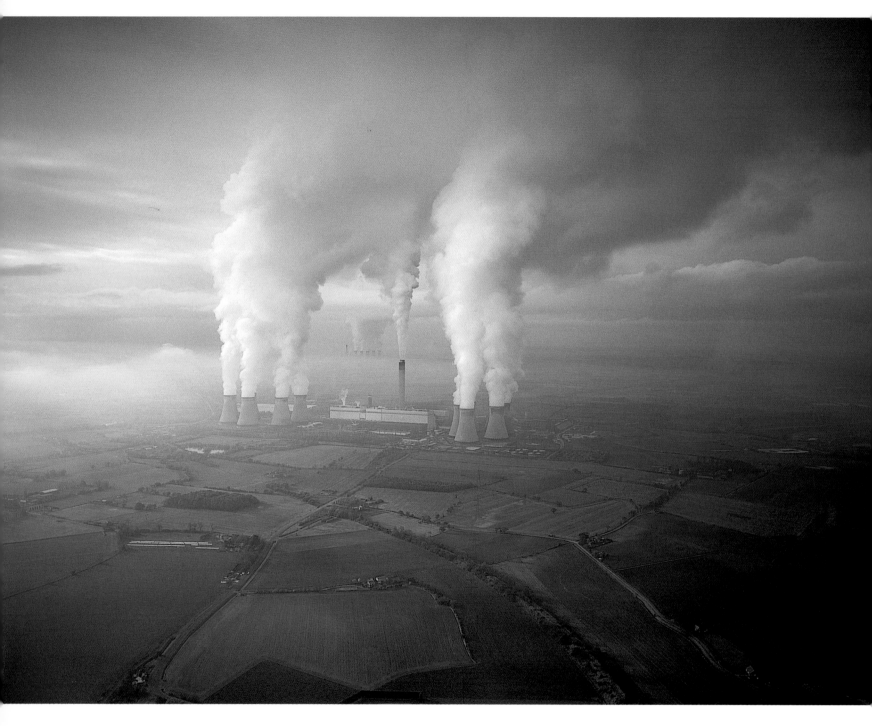

↑ Environment

From the air you get a fantastic visual impression of how humankind treats the landscape. Some areas are highly populated, others polluted, and still others seem hardly to be affected by human presence. Temperature inversions are easily visible from up here, by which I mean a reversal of normal temperature patterns which can be seen in our lower atmosphere. In wintertime,

a temperature inversion occurs when cold air close to the ground is trapped by a layer of warmer air. As the inversion continues, the air becomes stagnant and this traps the pollution close to the ground. In summer, the inversions are the product of hotter air trapping warm air. When you fly up where there is an inversion, it's easy to identify a thick yellow or purple line

on the horizon. A strange thing happens when you rise above it (at 3–4,000ft). You can see further through the air, and beneath you lies a layer of pollution. I have often taken images which have an environmental theme. Ironically, I am also horribly aware that by doing so I add to it, too.

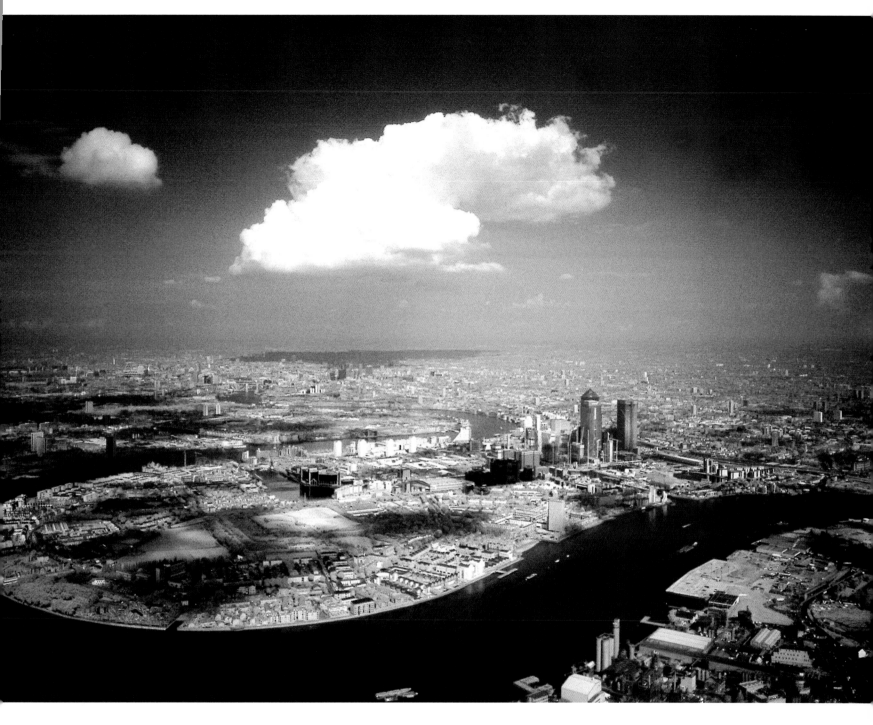

↑ **Isle of Dogs, London, England**
Agency: Ogilvy & Mather

I shot this ad using Ilford SFX 200 (an infrared film) and a Kodak Wratten 89B. When using SFX with a dark red filter, the film is exposed using only red light. Areas which reflect little red light, such as the sky, are low-density areas on the negative and dark areas on the print. Areas which are excellent reflectors of red light, such as green foliage, will be high-density areas on the negative and light areas on the print. There is little green foliage in this view but the clouds are brought forward as the blue skies turn very black. You can load SFX in subdued light as opposed to true infrared that must be loaded in total darkness. I had thought about using this and loading it up in a changing bag in the helicopter, but was prompted to be better safe than sorry. The filter I used is so dark that I could not see anything at all through the viewfinder. Luckily, having used this lens quite often, I was pretty certain of my result so I shot off a few films, bracketing to capture exactly the right exposure.

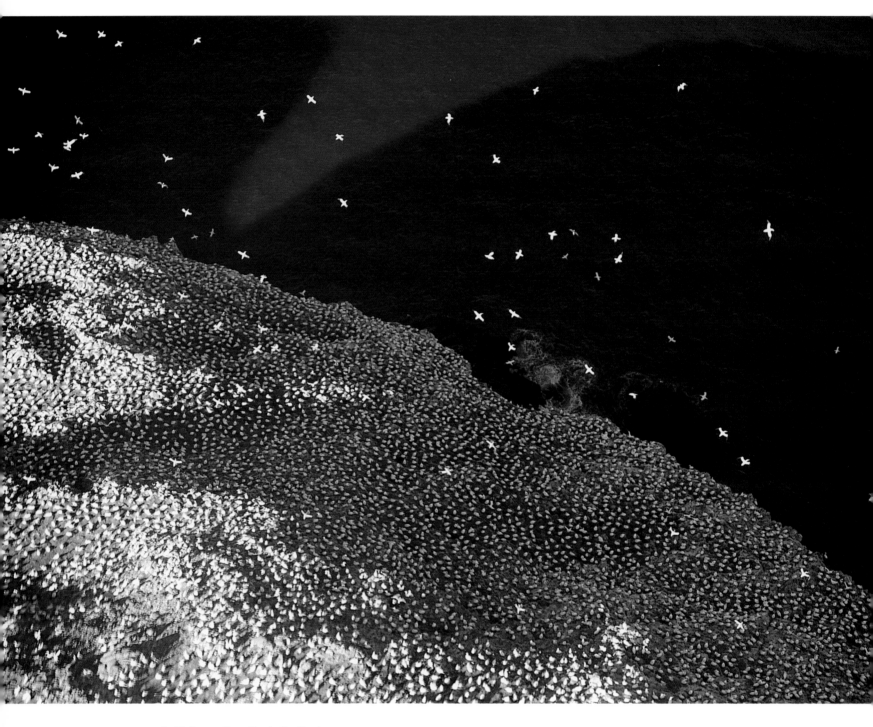

↑ **Birds over Bass Rock, Scotland**
*This tiny island off the east coast of Scotland is
often inaccessible from the sea because of the
high swell. It is populated by tens of thousands
of birds, and I flew there certain it would make
a great image. The rock face was engulfed.
We made just one pass from about 2,000ft,
dropping down in order to get the shot I wanted
without scaring the wildlife.*

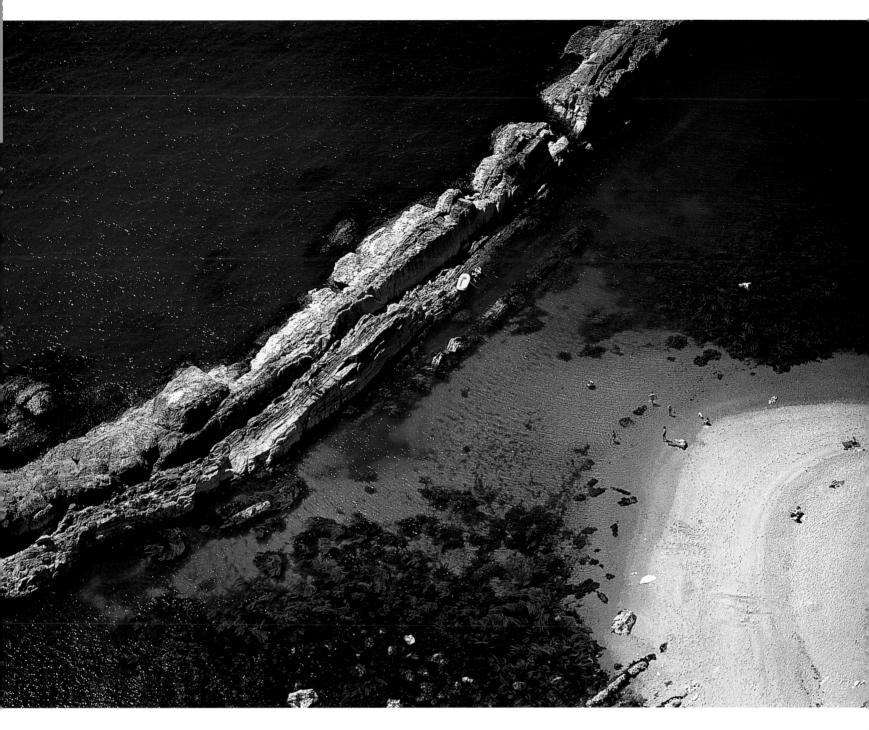

↑ **Rock outcrop in south Devon, England**
*Beautiful colors, interesting composition, people
to add scale. I always think it more interesting if
there are people in images like this; without them
it would be very difficult to have a sense of scale
in the image.*

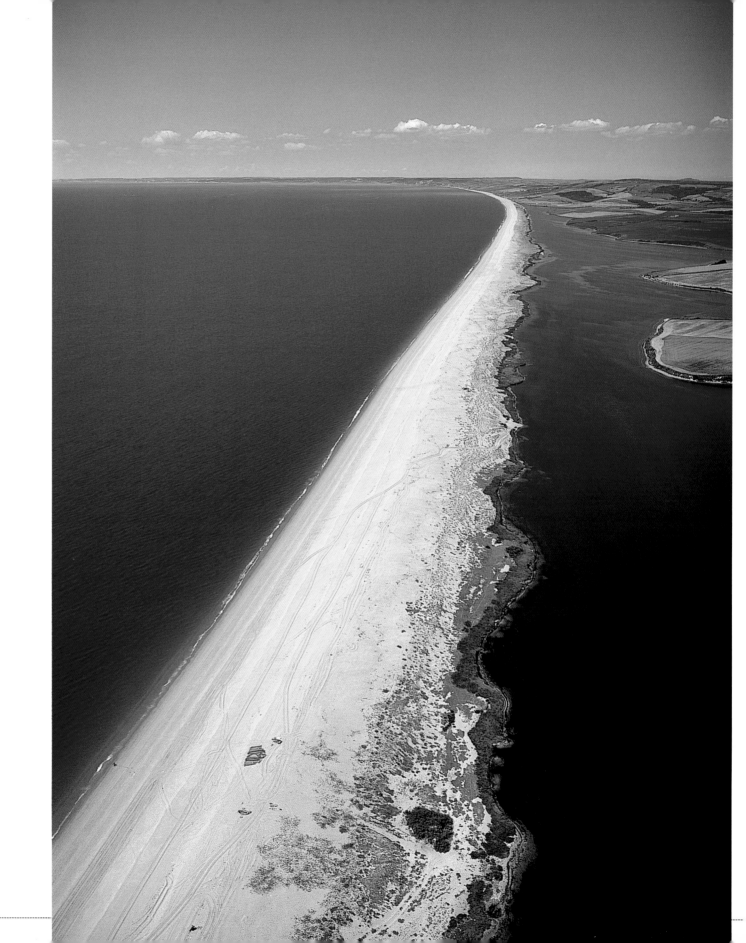

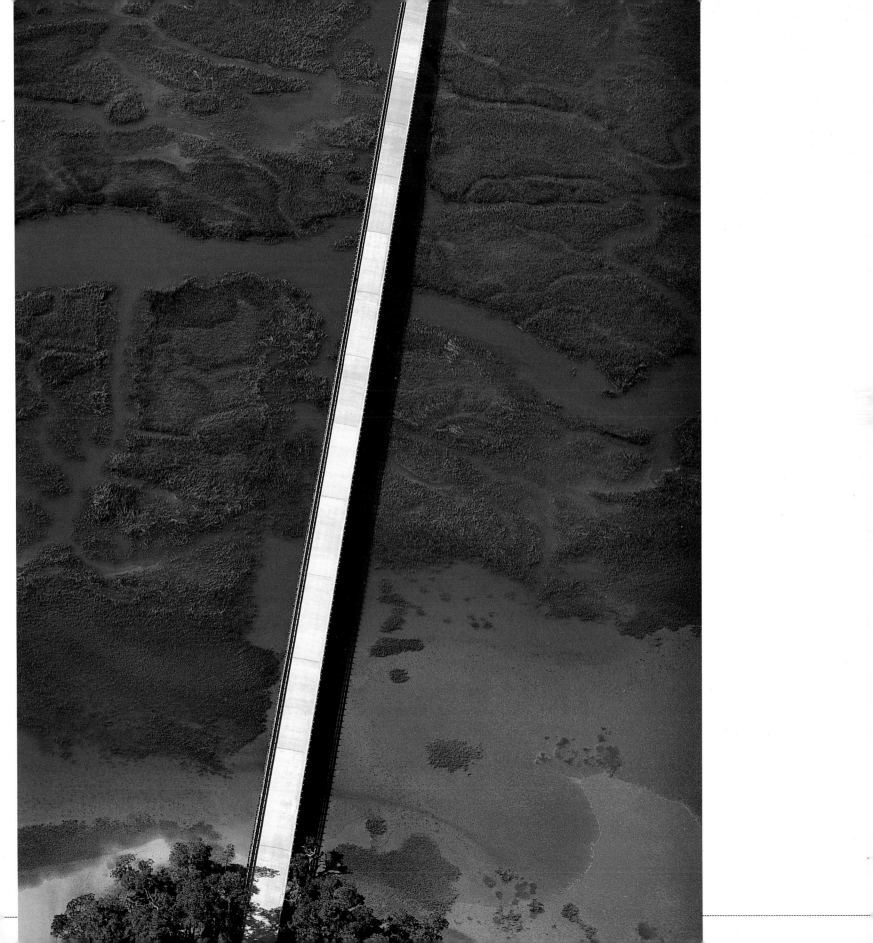

↑ Chesil Beach, Dorset, England (previous page)
This is one of those places you fly over that would be great to land the helicopter on and take a walk around. As yet, no-one has found a satisfactory answer to why Chesil Beach is the way it is, and its origin has been the subject of much debate. At around 18 miles long, Chesil beach (chesil means 'pebbles') has shingle rather than sand. Not that unusual until you realize that the size of this gravel ranges from pea-size at the west end to egg-size on the east.

Years ago I put down a helicopter on a tiny sandbank about a mile or so from the coast. The pilot and I thought it might be fun to land in the middle of nowhere, so we did just that. The sandbank was only about 40ft long and I jumped out with a video camera to record our stupidity for posterity. The pilot was shutting down the engine, which takes a couple of minutes, and I was just standing there looking at nothing but water. It was pretty windy so it took a while before I heard the pilot's urgent shouts, and by the time I was back in the helicopter the skids were sinking fast into the sand. I had visions of the tide rising, leaving us stranded, or with a very long swim back to shore. We pulled on the power as normal but were stuck fast. A lot more power and some very tense minutes later, and we were off again. Years later, I realized what might have been when another pilot told me how a friend of his in an old Bell UH-1 series Iroquois, known as a Huey, tried the same thing in Vietnam. He pulled too much power, popped the skids out of the sand, and turned the machine over.

↑ Walkway over bluff, South Carolina, USA
(previous page)
From the air, the 'sea islands' in South Carolina form a stunning, graphic habitat. You can see dolphins swimming up the shallow creeks at high tide and alligators basking on the muddy banks.

↱ Lilypads on a lake
Like the shot of the birds on Bass Rock (page 34), the perspective of great height makes the view an abstract one. The marine life of these waters is given greater context at the same time as it becomes less recognizable.

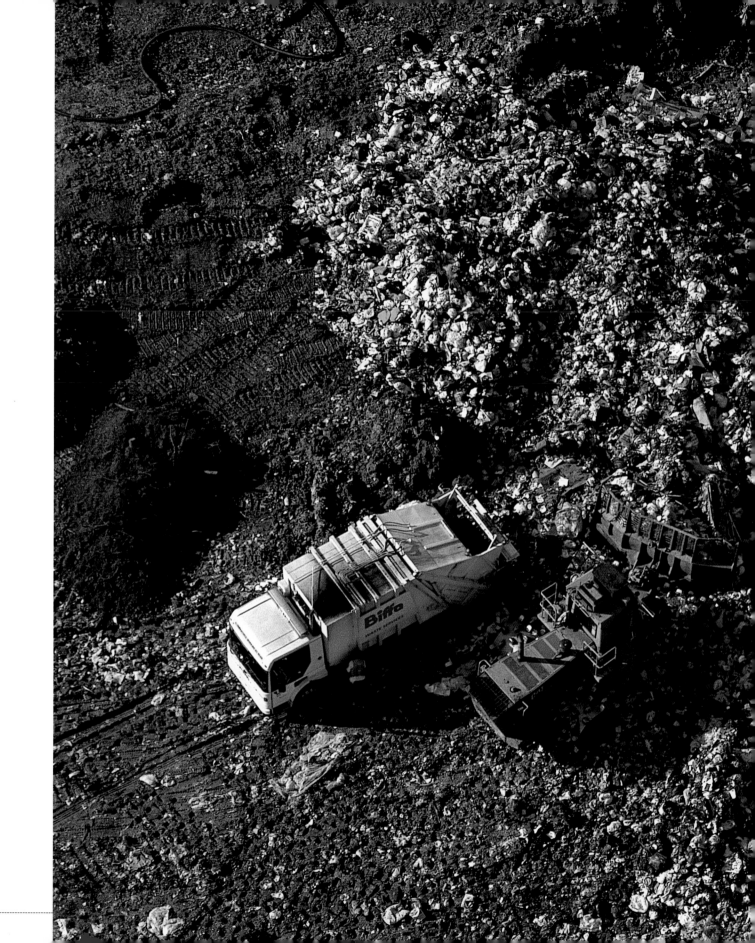

← **Landfill site and truck**
I'm often startled by images of the detritus of humankind, such as this one. From the ground, this would form a deeply unpleasant scene (and odor), but curiously, from above, the scene is both thought-provoking and, like a mad mosaic, visually stimulating.

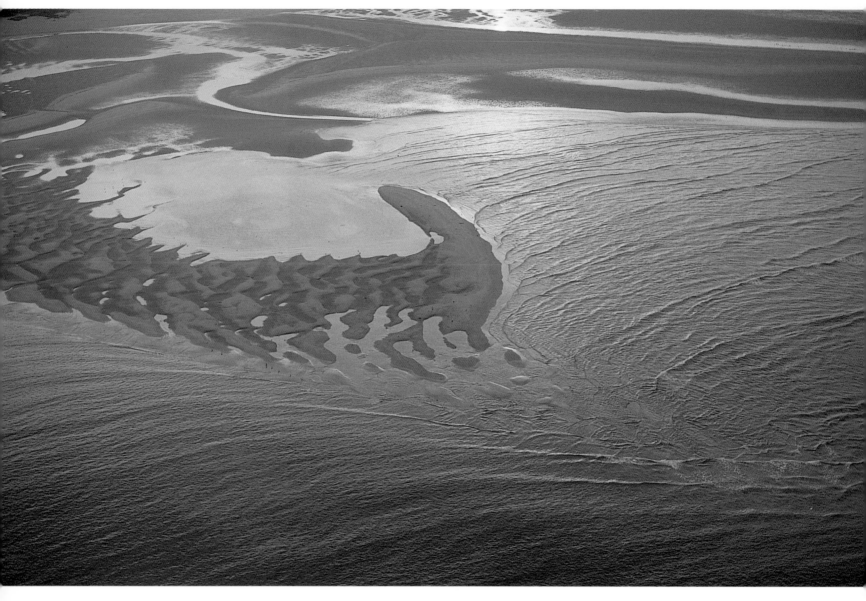

↑ **Sand banks**
I often find myself drawn to photograph locations such as this. The simple patterns created by the tide on the sand are incredibly beautiful, especially in contrasting light. I shot this from about 800ft, but without any reference to scale, it could easily have been 100ft or 3,000ft.

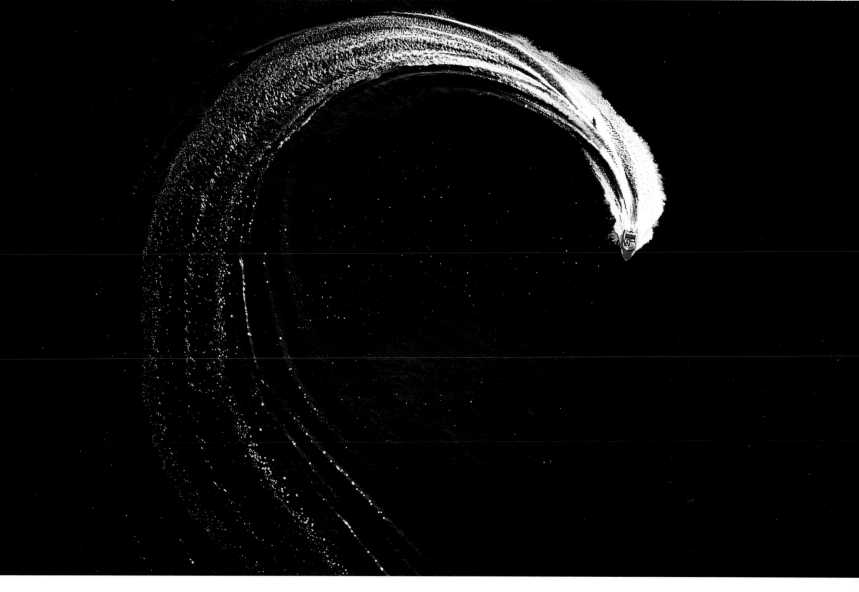

↑ **Waterskier**

I had been shooting for three years and had published two books when my portfolio was called in by an agency I have decided I will not name and shame. They were working on a huge campaign for an international airline. The art director was pitching to the client to choose his idea and called me in to talk it over. His idea was to use graphic aerial views of all the places around the world the airline flew to. He went on to make some mock ups of the adverts using my photographs, and presented them (including the photograph here) to the client. The idea was well received and given the go ahead. I spent a few days calling pilots in the destinations we had to photograph and my agent and I put together some costings. Being relatively inexperienced I was a little uncertain of my daily rate and so

called another, more established photographer, who was also a member of The Association of Photographers, for some advice. The quote was accepted by the client and I blocked out a few weeks in my diary for the shoot. A week passed without word so I phoned the agency to find out what was happening. To my dismay I was told that the whole idea had been canned.

I had already put in a lot of work and, despite being pretty upset, remained stoical. Six months later I was pretty cross to see a very similar campaign to the one I had been told was cancelled splashed all over the press and on poster sites. One of the images was of a beautiful palm-fringed beach and sea, and sure enough, there was a speed boat and water skier pulling exactly this pattern. Plagiarism, naivety?

I'm not sure if there's a moral to this story, but I learned a lot from that experience and won't serve up a job to another photographer in this way again.

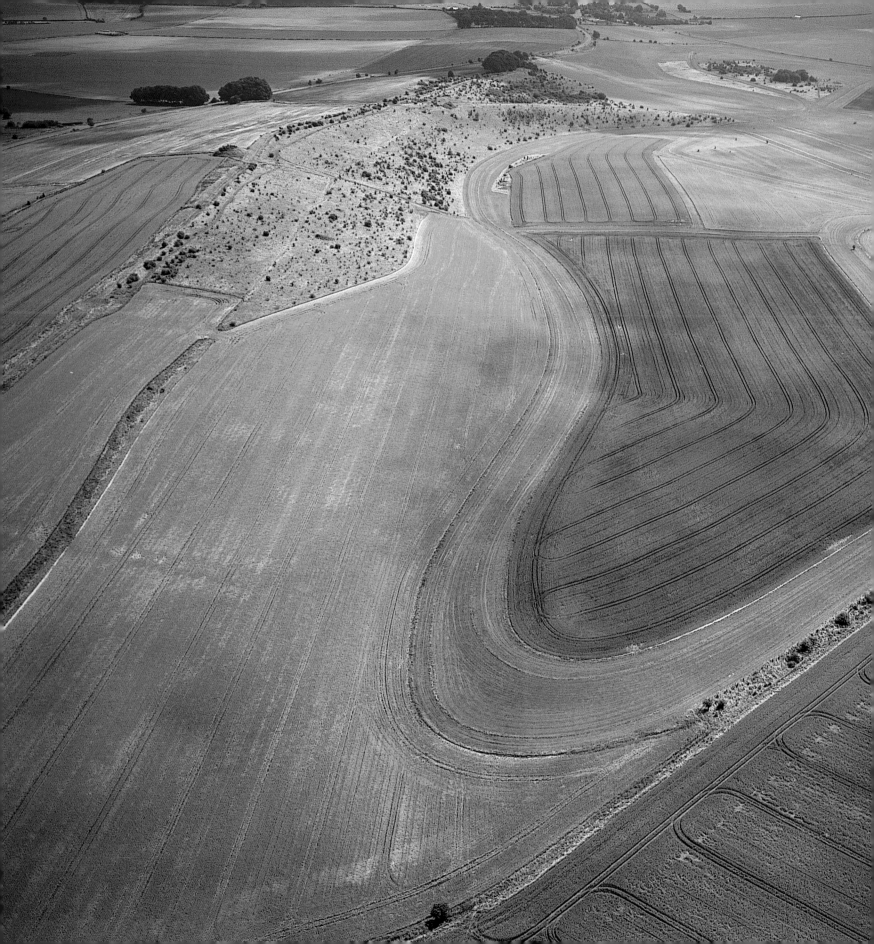

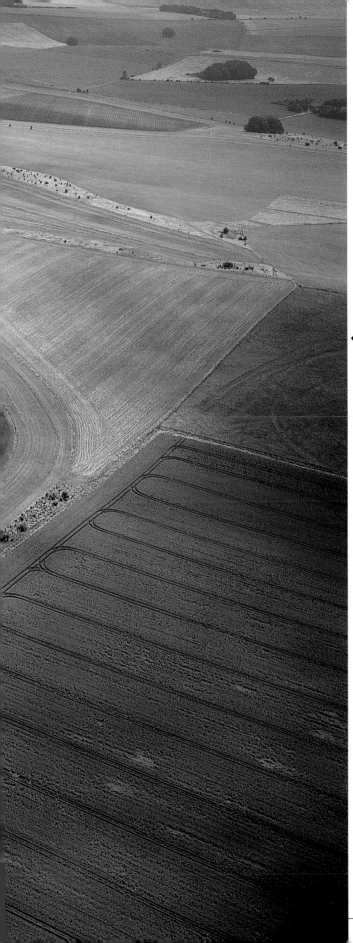

Cornwall, southwest coast of England

I shot this image while producing a book on the West Country for Random House publishers. I had flown down for the day with the pilot, Ian, in a four-seater R44 helicopter. Ian had been booked for some aerial film work the next day so we were due to fly down to Devon and Cornwall, shoot a few locations, and get back to our base later that evening. Just before we were due to take off Ian's booking was cancelled, so we thought we would work our way around the coast and find a place to stay at the last minute.

Later that afternoon I pulled out my trusty book of British helipads which lists most of the hotels in the UK where you can land a helicopter. A quick look at the map revealed a hotel on its own tiny island, just off the south Devon coast. Perfect. Having booked up a couple of rooms and let them know we'd be there sometime that evening we set off again for another sortie of photography. A little later we circled the small island and set down the helicopter on the landing site.

Bearing in mind that on departure we had assumed we would be back the same day, we had no spare clothes packed. It had been a particularly hot, sunny day and I, for one, could have done with a shower. A very well-dressed concierge greeted us and asked if he could help with our luggage. 'Sorry,' I told him, 'but we don't have any, in fact we only have the clothes we are in: jeans and t-shirts.' He very politely informed us that it was strictly black tie for dinner. It turned out that we had landed on Burgh Island, at a beautiful Art Deco hotel. Everybody dresses accordingly, with sleek cocktail dresses and black tie for the men. We had a drink at the bar feeling just a little out of place, and then dinner tucked away from prying eyes in a back room of the hotel. Ian and I left the next day deciding that, in future, we would always pack a black tie – just in case.

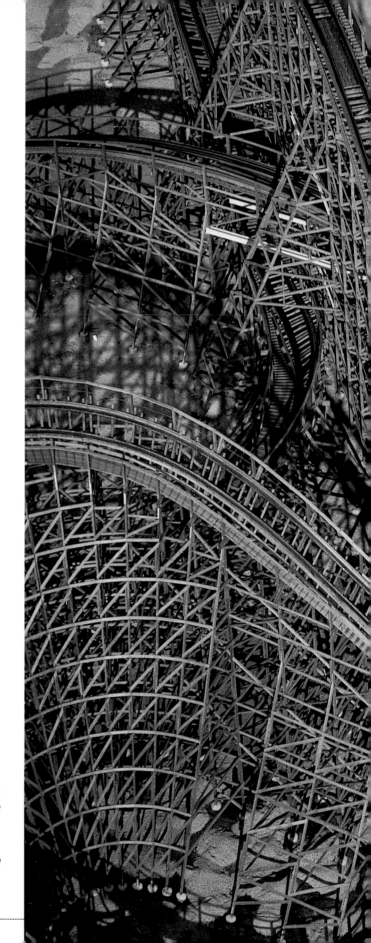

➔ Roar rollercoaster, Six Flags America, Baltimore, USA

While shooting a book on Washington DC, I saw an ad for a theme park and thought I would go and take a look. From the moment I saw this rollercoaster, I knew it would make a dramatic image, if only I could get close enough. In order to achieve the desired height, I chartered a twin-engine squirrel helicopter and shot with a 165mm lens. We had to hover around for quite some time in order to capture the car going round, but I think the image is richer for this detail. I used both color and black-and-white film; I feature the color version here, but the black-and-white image went on to win an award from the Association of Photographers in 1999.

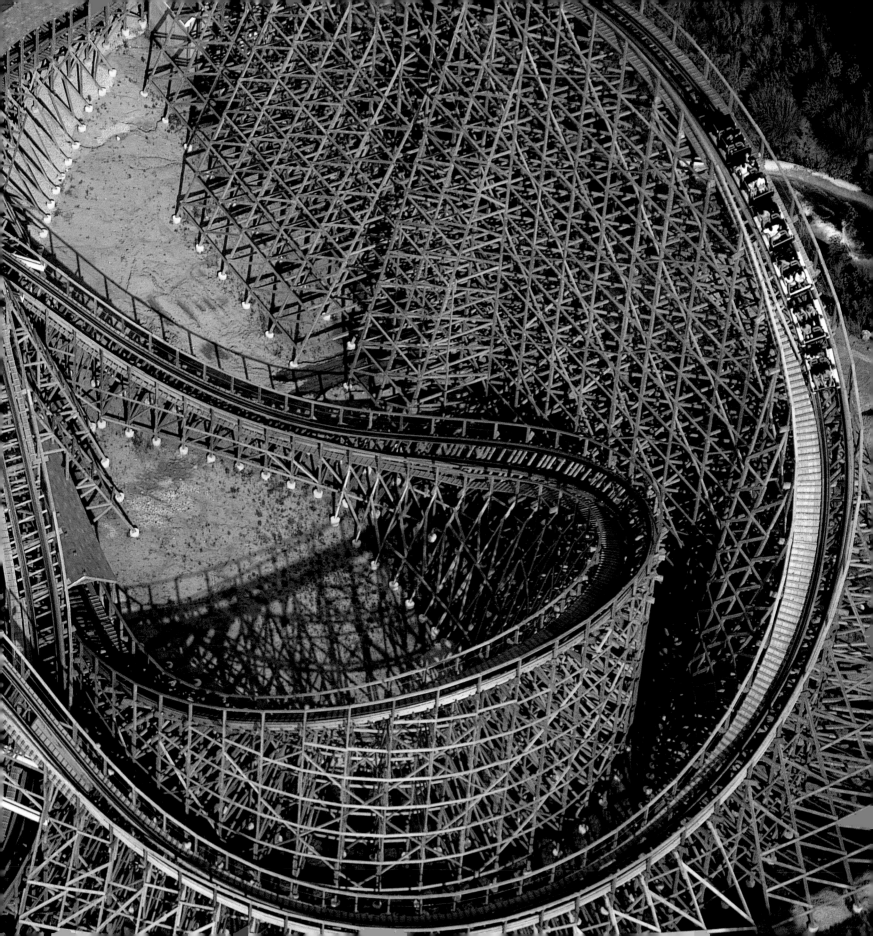

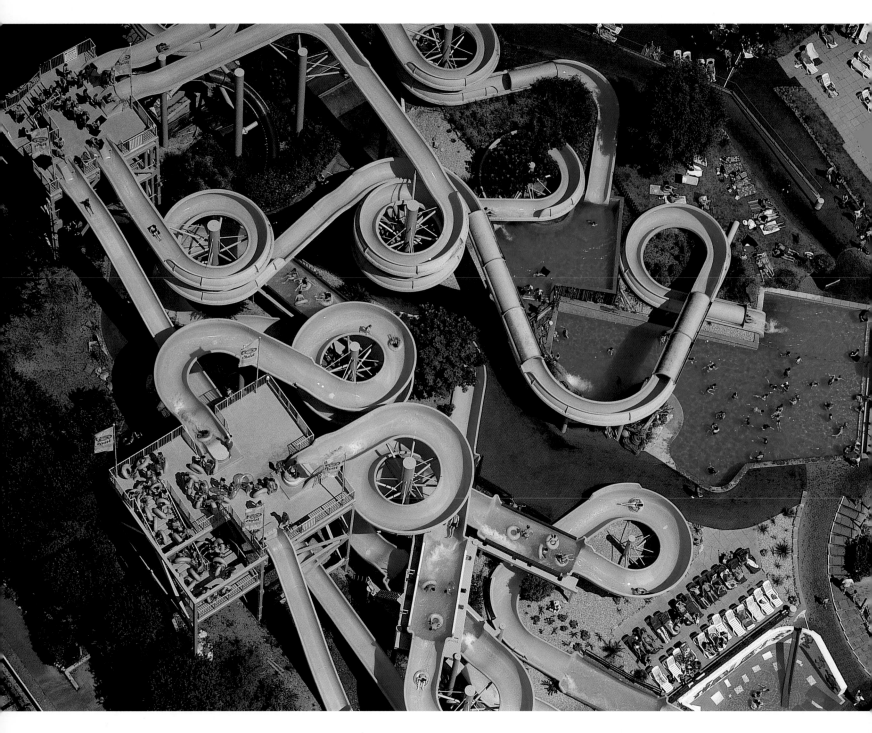

↑ **Waterpark, Paignton, Devon, England**
*Like the rollercoaster in Washington DC, this
waterpark on the southwest coast of England is
a graphic illustration of the crazy grandeur of the
structures that we build to entertain ourselves.*

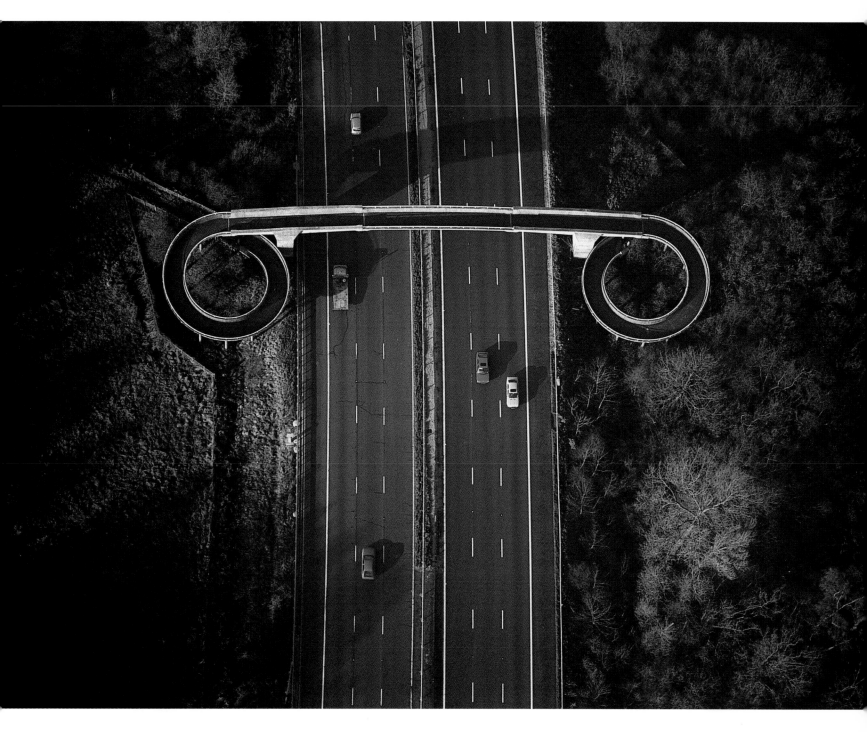

↑ **Motorway bridge**

This bridge is just down the road from where I live. I have driven along this stretch hundreds of times, and from the ground you wouldn't give it a second glance. The bridge is not for pedestrians, but instead is used for cattle to get from one field to another since the motorway was built, carving a huge gash through a farm, which is why it has a curved pathway rather than steps.

I like the image because the bridge and motorway make a strong, but simple, composition.

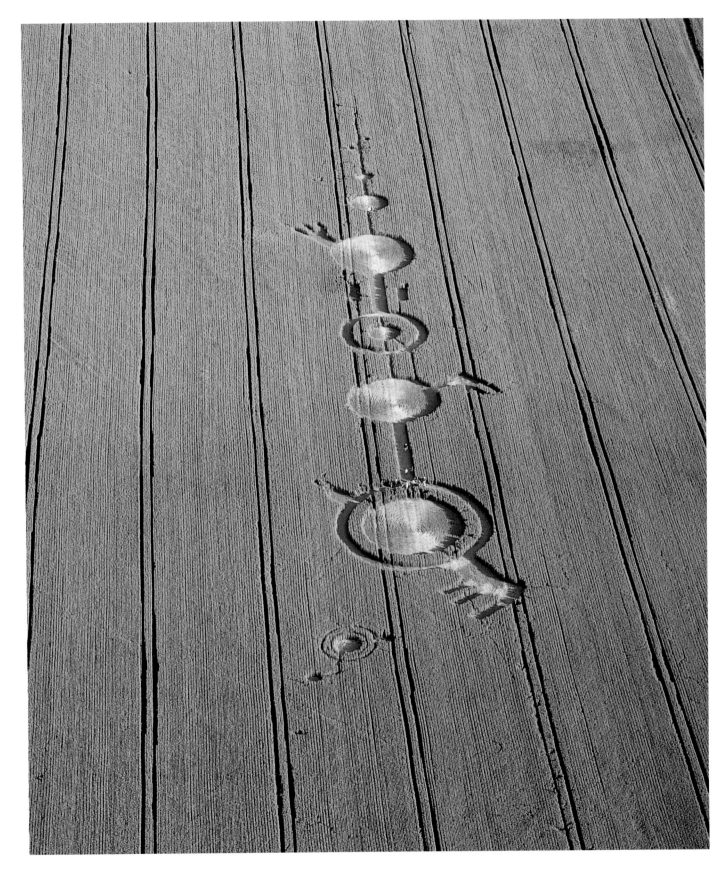

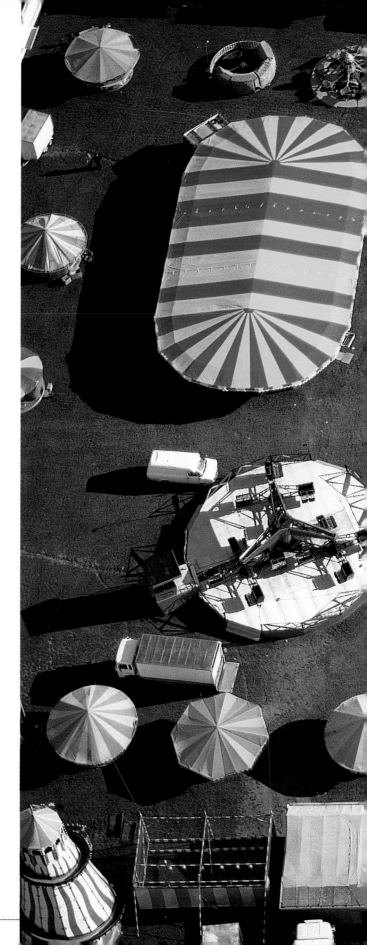

Crop circle, Alton Barnes, England
(Previous page)
I have seen and photographed quite a few crop circles, but this one, taken back in 1990, is still the most interesting for me. A writer I was working with at the time told me about it, and I flew down to the site in a microlight and then biked the black-and-white film up to a newspaper in London that wanted to run a story about it. Bizarrely, the film turned out to be blank – a first for me in my career as a photographer, and something that has never happened since. I flew back and shot it on transparency, which thankfully worked fine. The images were consequently distributed to hundreds of newspapers around the world via London agency Camera Press.

Last year I sold the image to Freddie Silver, a very knowledgeable author on the subject of crop circles. He told me that countless photographers have had the same problem shooting crop circles. Silver wrote a great book about what, in his opinion, are the real reasons behind the circles. Hoax, conspiracy, or of extra-terrestrial origin, I have an open mind on the subject.

Thames Barrier, London, England
(Previous page)
I shot this for a book called 'London from the Air'. Flying over London, away from strictly controlled heli routes, can be very expensive. The CAA in Britain will only allow broad access over the capital in twin-engined aircraft. A 'twin squirrel', as they are known in Europe, is chartered at several hundred pounds per hour. Once you include positioning time and getting to and from the location, you can easily have burned a serious hole in your pocket before even taking off your lens cap. And once you are over the city you may be asked to divert from your location to let other aircraft pass, such as a police helicopter or an air ambulance.

↱ **Funfair, Blackheath, England**
For me, this image satisfies as both a great social document of a great British tradition, but also an interesting aesthetic exercise. I'm startled by the regularity of the shapes and the spaces between them. From above, that's easy to map, but on the ground there is no perspective to help you.

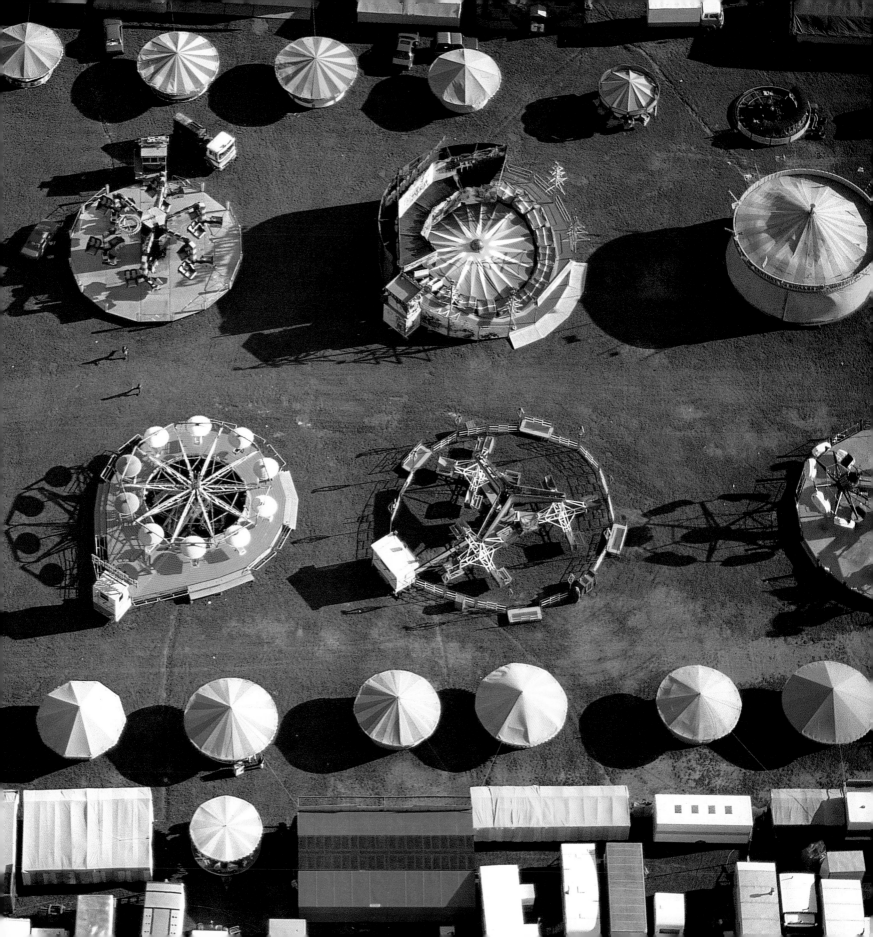

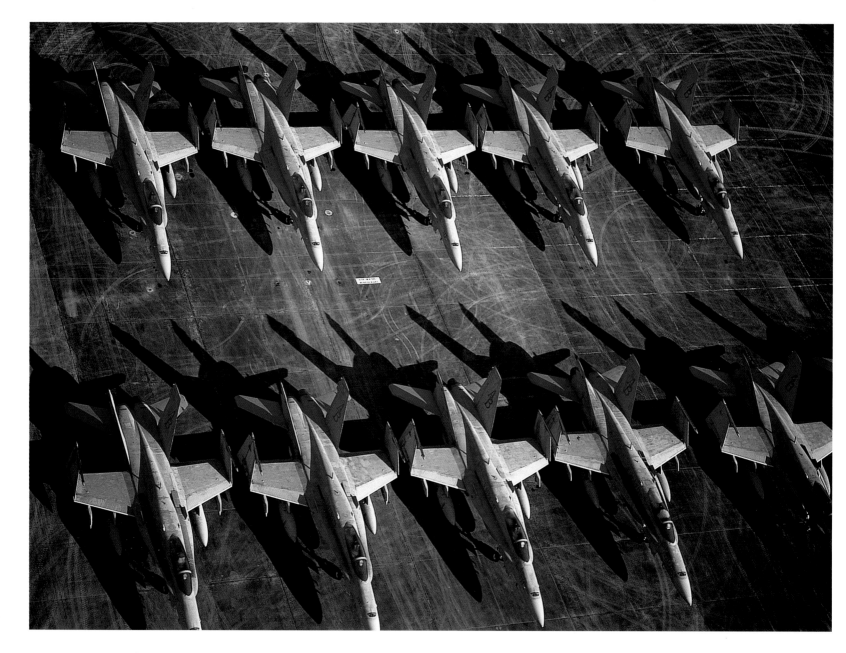

↑ **American fighter jets at Beaufort Air Station, South Carolina, USA**
This photograph was part of a series commissioned by publishers Wyatt and Co. for a book on South Carolina. In Europe it would have been practically impossible to capture a similar image due to the tight flying regulations at this height over military airports, but this image was taken before the September 11 tragedy in New York.

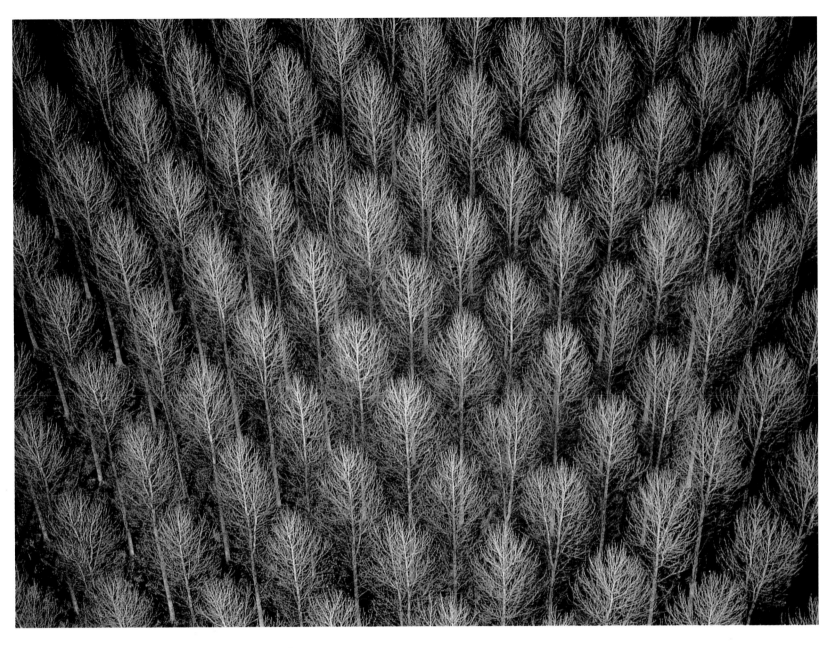

↑ **Deciduous trees in fall, Berkshire, England**
*This image was one of the very first aerial views
I took from a microlight. The machine was a
simple two-seater powered by a tiny Rotax
engine. To change films, the pilot had to lean
forward as much as possible, giving me just 4in
of space to work with.*

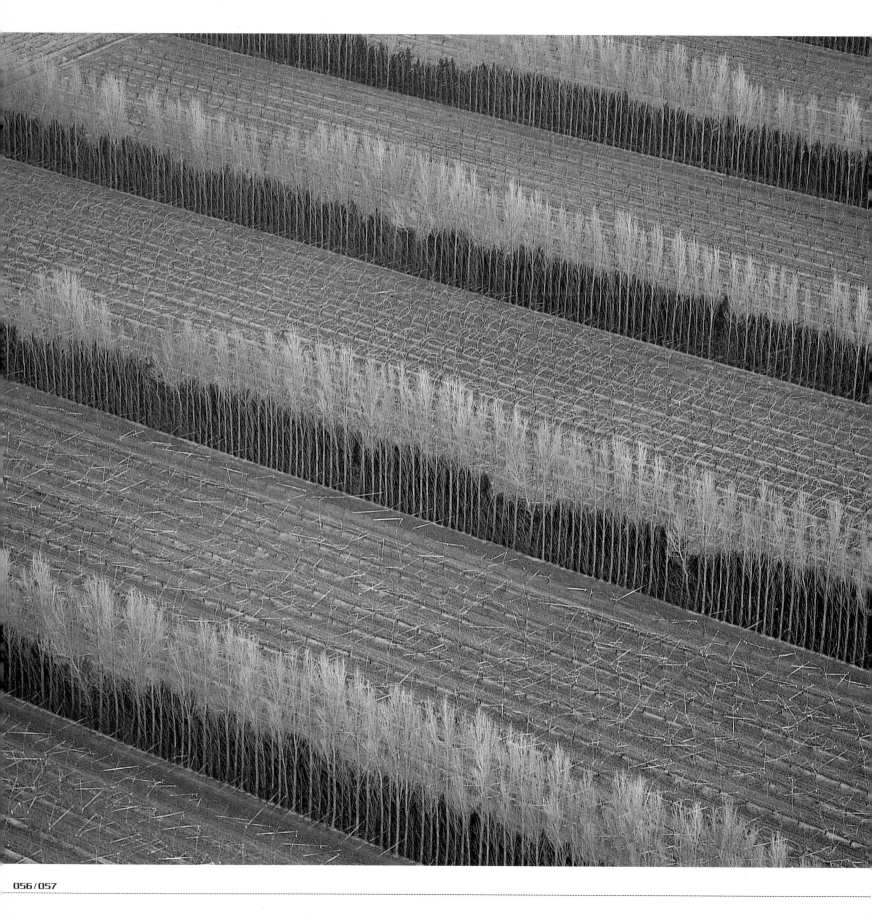

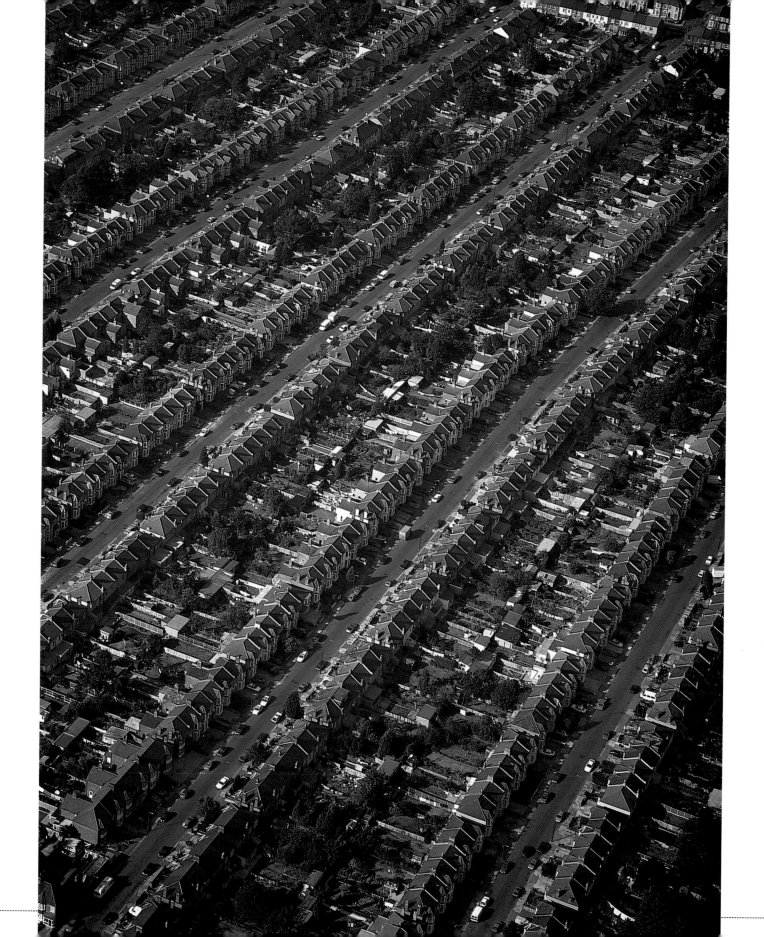

Rows of trees between fields (previous page)
This is one image of many that I've taken that remind me of woven fabric. In fact, the tall trees that separate these fields are probably intended to form windbreaks.

Terraced housing, Ilford, Essex, England (previous page)
These strictly regimented rows of streets are part of a late nineteenth-century development, which have very Imperial names such as Khartoum, Madras, and Bengal.

→ **Blue covers on a fruit farm, southern France**
This is one of those locations you see when any amount of head-scratching can't help you understand what the view is. Afterwards I even asked farmers about it. I can only guess that the covers are there to either protect fruit crops in some way.
I like the texture of this image, it has the look and feel of a piece of blue quilting.

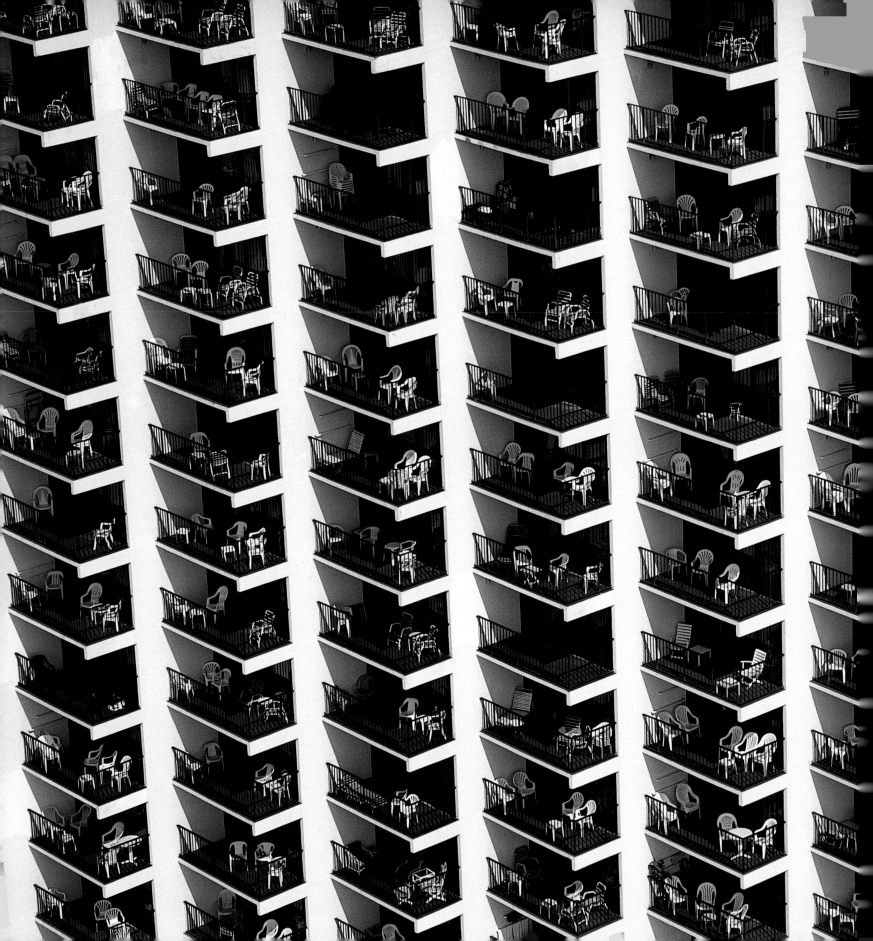

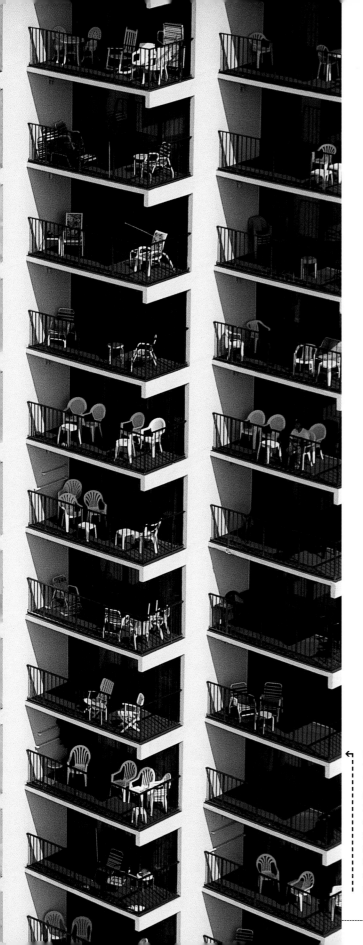

Holiday apartments, Myrtle Beach, USA
This is not so much an aerial as a frontal view. The balconies of this building overlook a beach, and we flew up and down the strip at around 200ft. Occasionally I would ask the pilot to drop down a little, and on one such occasion fitted a telephoto lens to my camera in order to be able to get a strong, graphic crop like this. I wanted to capture only the balconies of the building, cropping out anything that would distract from the ordered lines.

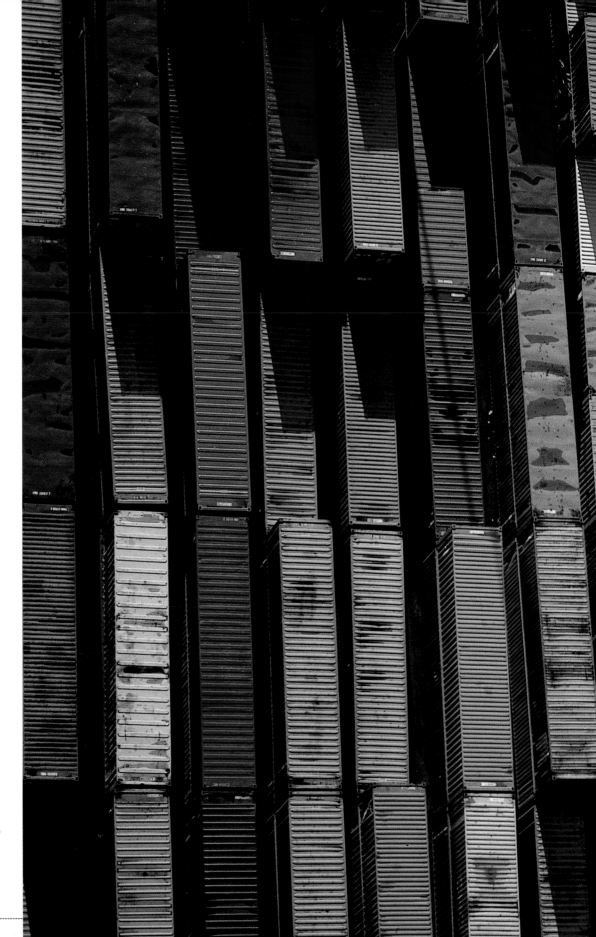

→ **Truck containers, Dublin, Ireland**
*For me, this image is another example of the way
in which the perspective of an aerial view adds
a different dimension to the scene. It might be a
mundane subject, but the patterns and colors
make it a pleasing graphic image.*

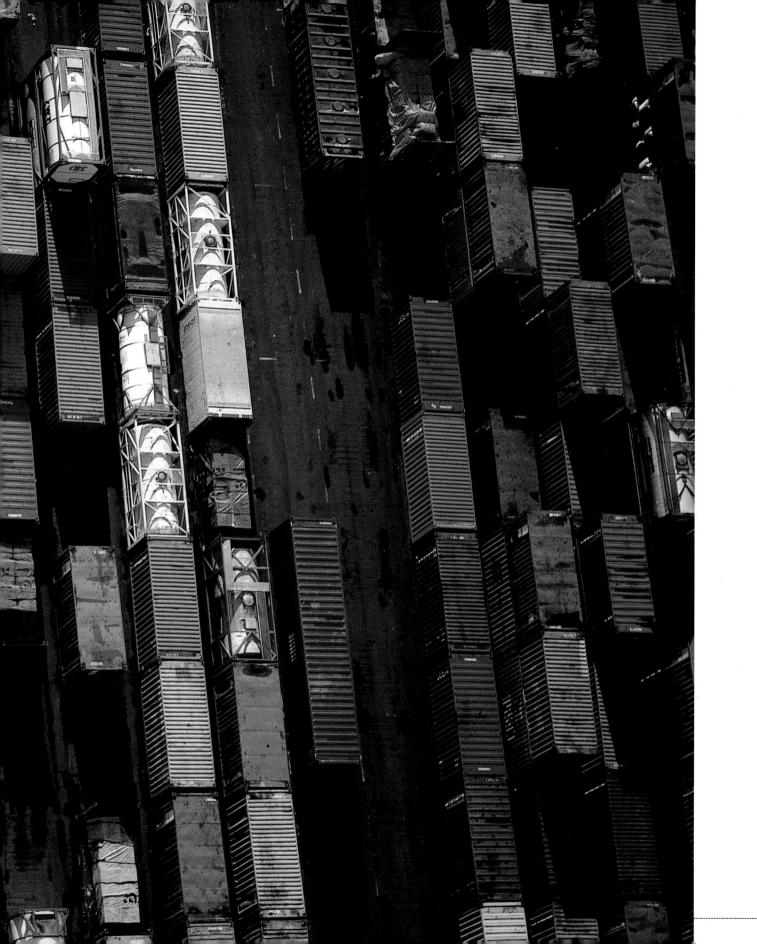

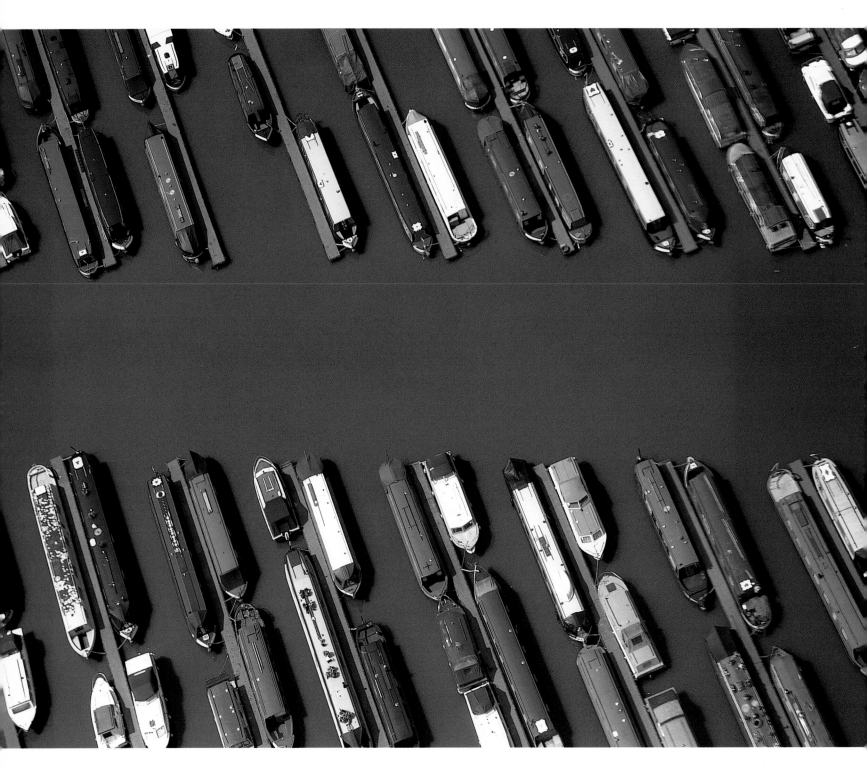

↑ **Tethered narrow boats**
*I like the way this image and that of the road
toll in France mimic each other in their
composition, and represent the myriad ways
we find to 'escape'.*

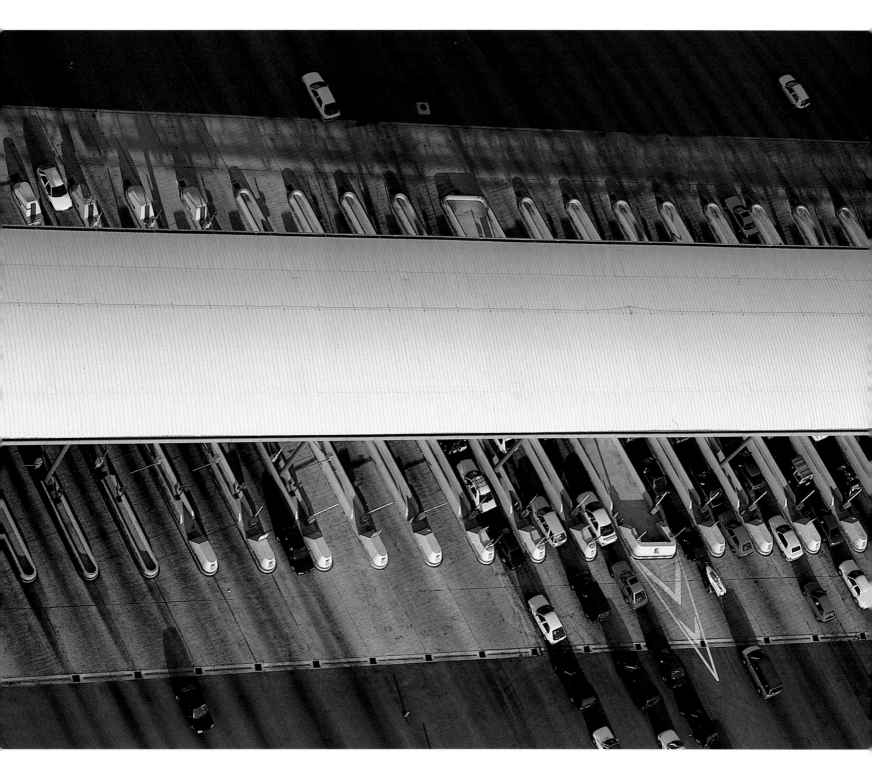

↑ **Road toll, France**
Road tolls are a long-established institution of motorway travel in Europe. Just like everything else, this image shows how human beings attempt to 'order' chaos (and make money out of it, too).

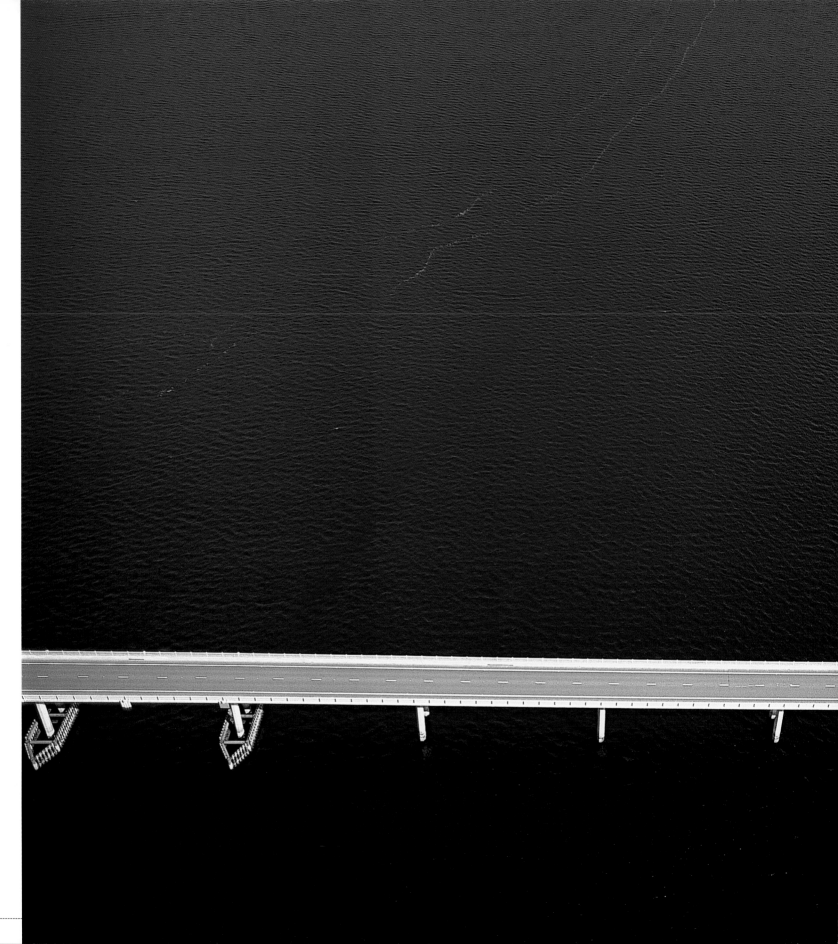

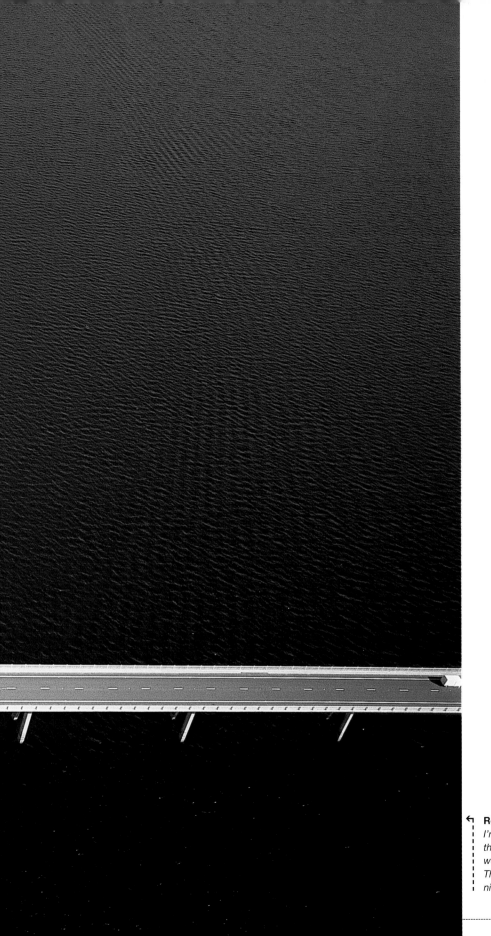

Road bridge, Florida Keys, USA
I'm impressed by the drivers who journey over this bridge every day. The image works really well as a simple relationship of line and color. The clear light on the stretch of road stands out nicely against the dark blue of the water.

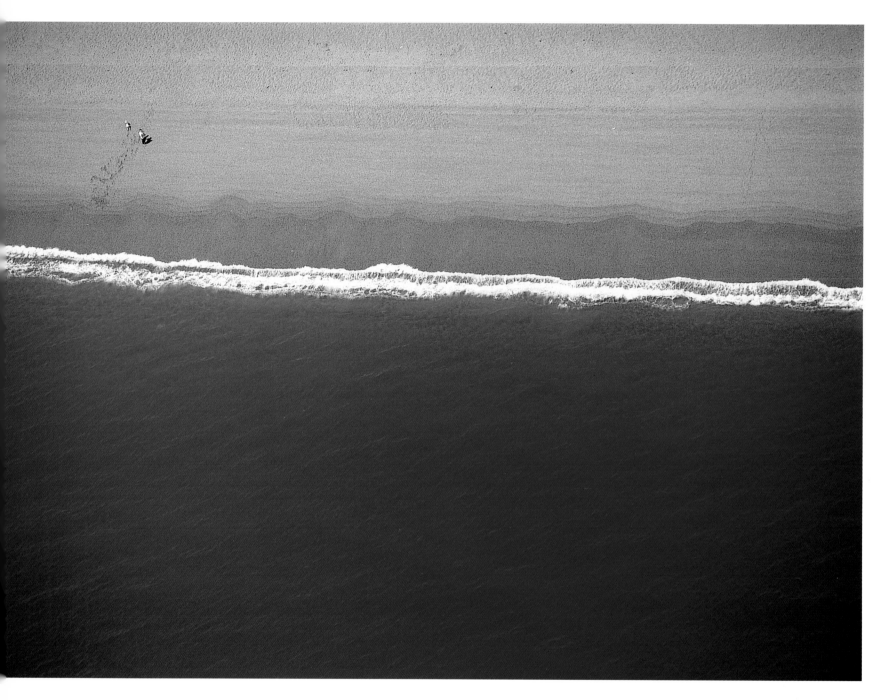

↑ **Beach in Scotland**
*This is one of a sequence of images that I shot
for a series of ads I was working on. Trying to
shoot the image so that the tide forms a line
along the beach is a matter of luck and good
timing – but each time it looks different.*

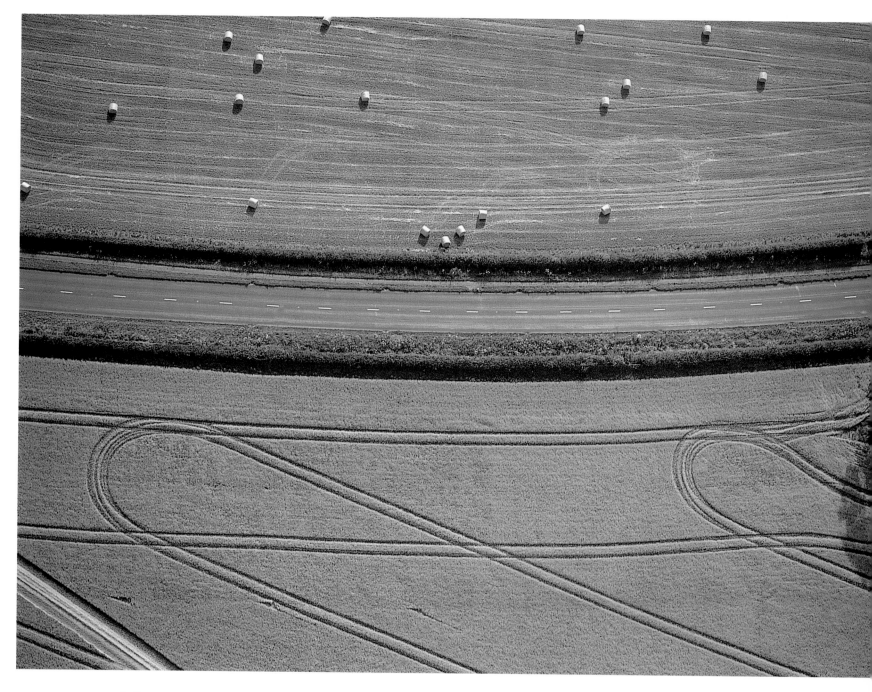

↑ **Road and hayfields**

This is a very English image. It reminds me of long drives as a kid. In many ways it is quite mundane but it is one of those 'found' images that shows up the jigsaw-like nature of our landscapes.

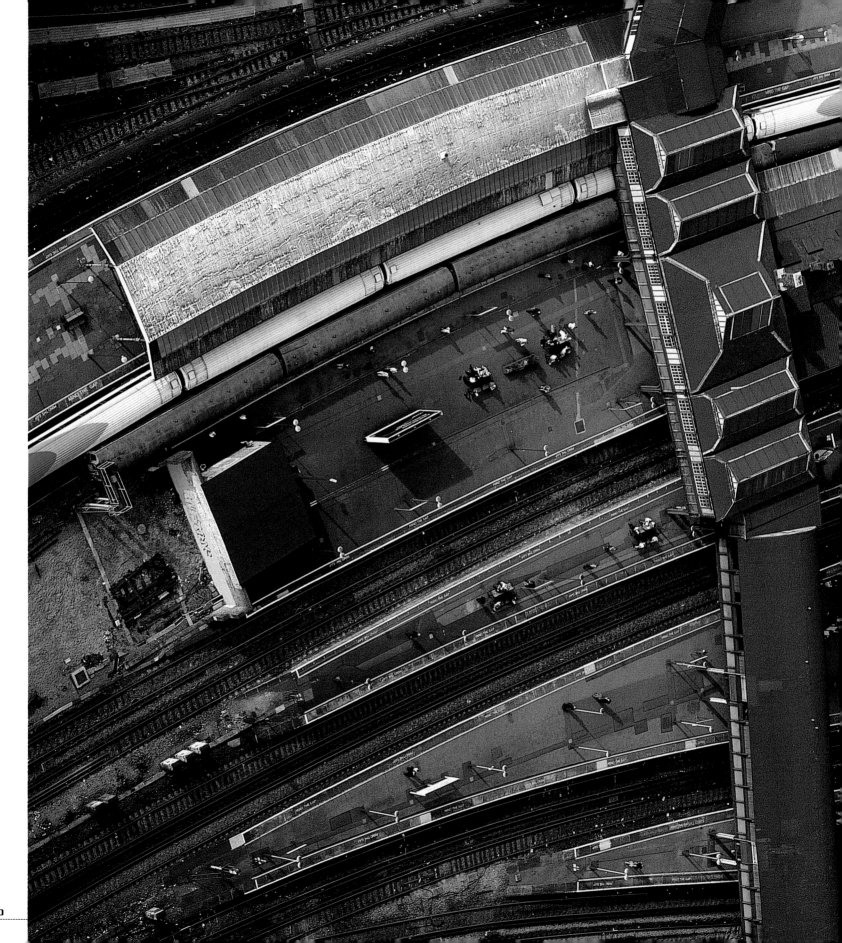

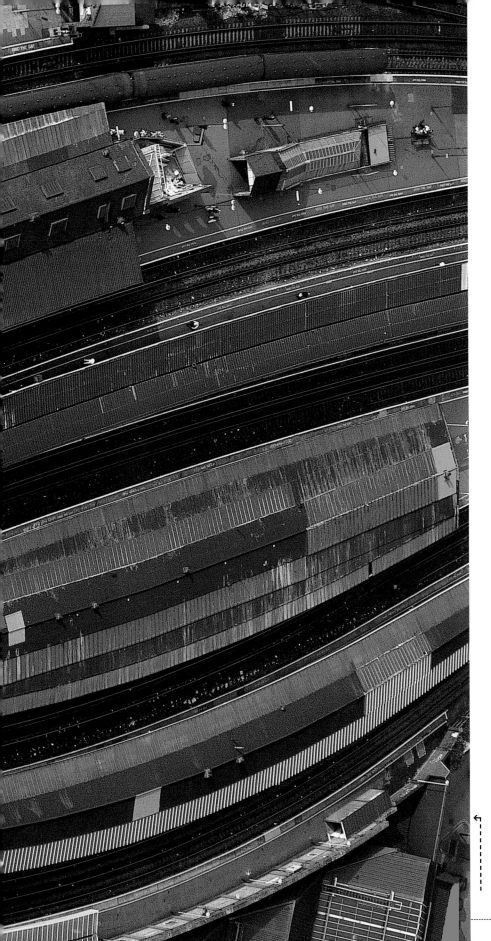

Clapham railway junction, London, England

*Taken for a series of ads for London Transport.
The art director went for more conventional
oblique images that I shot in the same series,
but I think this image works well as the interest is
in the details.*

⤵ Chrysler Building, Manhattan, New York, USA

This is another in the sequence of images that I have shot of the Chrysler Building in Manhattan, New York. This one is in color and gives a great impression of the way that this American city, like many others, is divided into distinct 'blocks'. It also shows how beautiful some of the architecture of these buildings is.

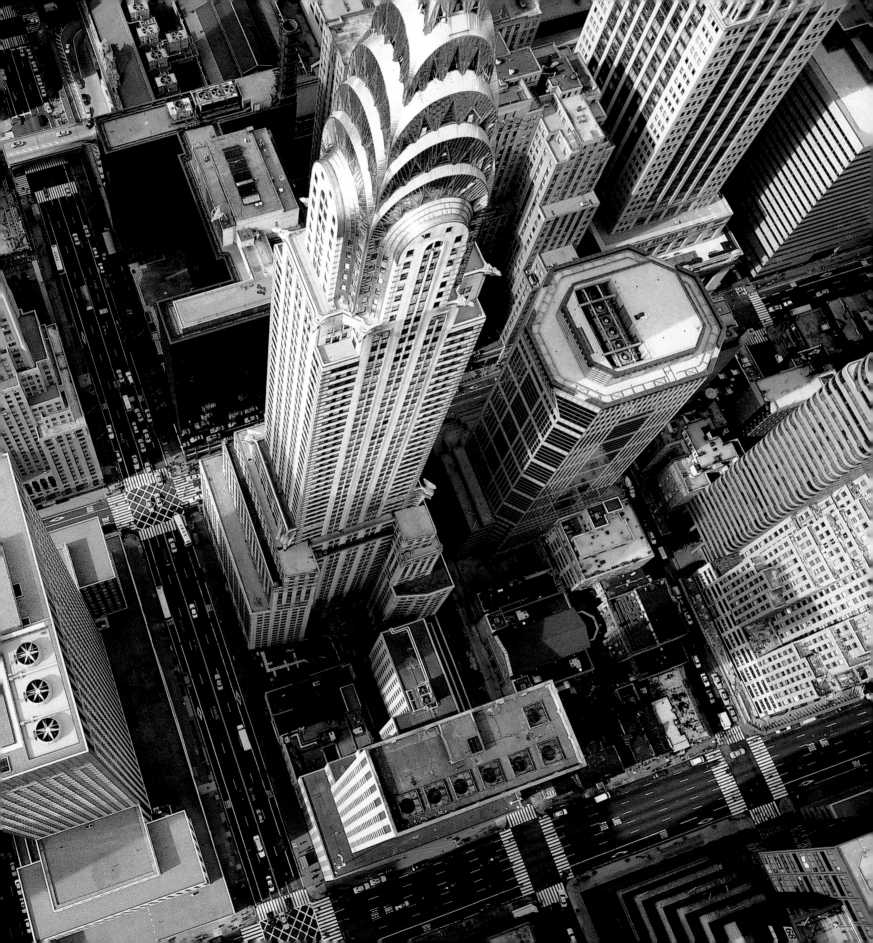

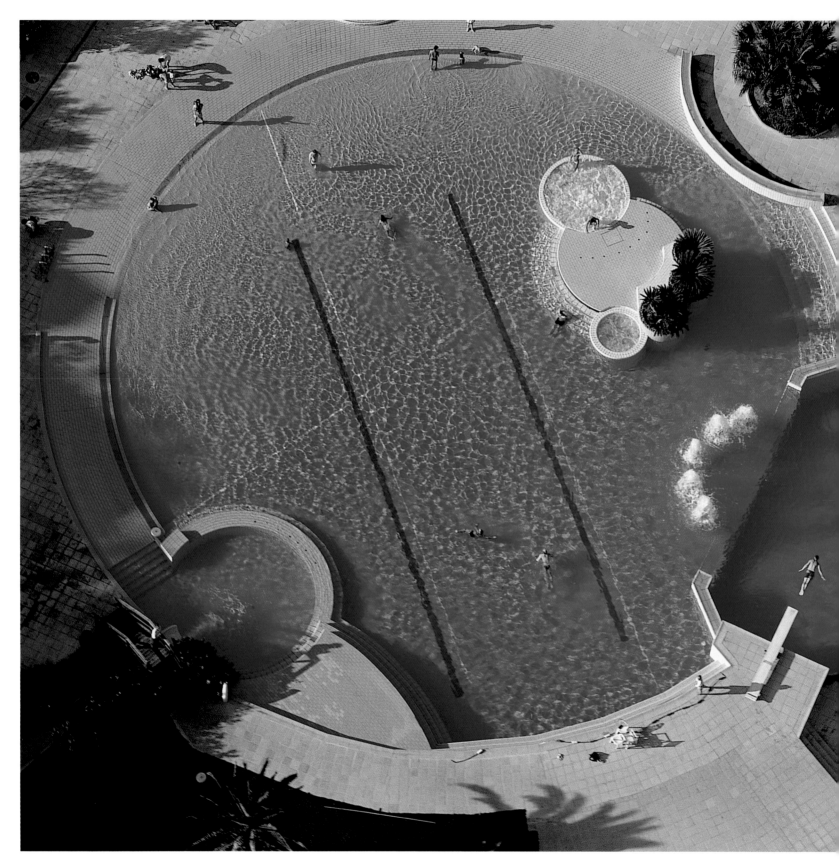

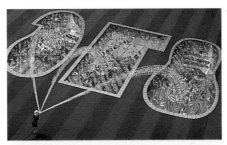

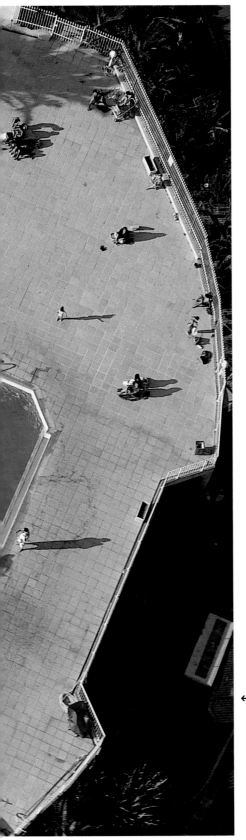

← **Swimming pool, France**

I must have circled this swimming pool for 15 minutes before I got the shot; I was flying in some of the strongest winds I have ever known. Heading into wind we were achieving about 20mph, and as we swung downwind our speed over the ground would suddenly increase dramatically. I didn't realize it at the time because of the turbulence, but back at my lightbox I was thrilled to see I had achieved my aim of capturing a perfectly executed dive.

← **Swimming pools**
Agency: Saatchi & Saatchi

This image has been retouched so much you might not believe it began as a series of original photographs. I was briefed by an art director and copywriter via a series of rough sketches, and the first thing they needed from me was a quote, broken down into the respective items. Once the quote was given the go ahead I spent a week scouting both for suitable swimming pools and a large grass lawn on which to shoot the hose and water feature. We found three suitable swimming pools and, with a little monetary persuasion, got permission to use them for the ad. I also found a huge lawn that was owned by a conference centre and again obtained permission to use it. A male model was found and suitable clothes despatched by a hire company.

The first scene to shoot was the model spraying water onto the grass lawn. We needed two fire engines to create enough water pressure so that it could be seen from a couple of hundred feet away. The crew duly instructed our model in the use of some pretty powerful hoses. I was in contact with a ground crew by radio from the helicopter and we spent the afternoon shooting various different viewpoints to give the retoucher plenty of imagery to work with.

Next we did the same shot at one of the swimming pools, and then shot two more pools without any crew or fire engines. The photographs were sent up to the agency who said everything looked great and started work on the retouching. Late on Friday afternoon the next week I received an urgent call from an art buyer at Saatchis who said they needed a shot of the model spraying the water, but this time shot against a black background rather than the grass. Apparently the retoucher was having some difficulties in picking out the water and needed this extra shot. "Oh, and by the way, we need the film here first thing Monday morning," she said before putting the phone down.

'Black background?' I thought and got on the phone to some airports, where I figured I might be able to hire the runway for a couple of hours. No luck there, either in use all weekend or the tarmac was gray rather than black. 'Right then,' I thought, 'I'll get a few hundred feet of wide, black material and simply cover the lawn with it.' Half a dozen phone calls later and I had sourced a suitable supplier. Now all I needed was six friends willing to give up their Saturday morning and help me peg down several hundred feet of material. So there we were the next morning with two fire engines, a helicopter and a group of people pinning down black material to cover up a green lawn. And yes, the film was at the agency first thing Monday morning.

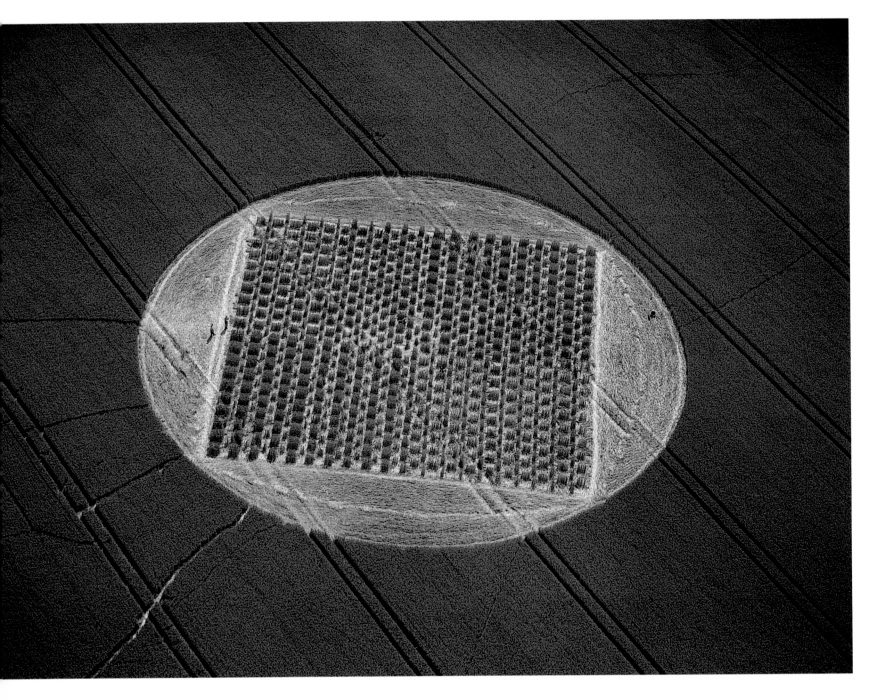

↑ **Crop circle near East Kennet, Wiltshire, England**
Taken in July, 2000, from above this one looks like some kind of bizarre game. The circle has a diameter of 55m with a central square comprizing many smaller squares.

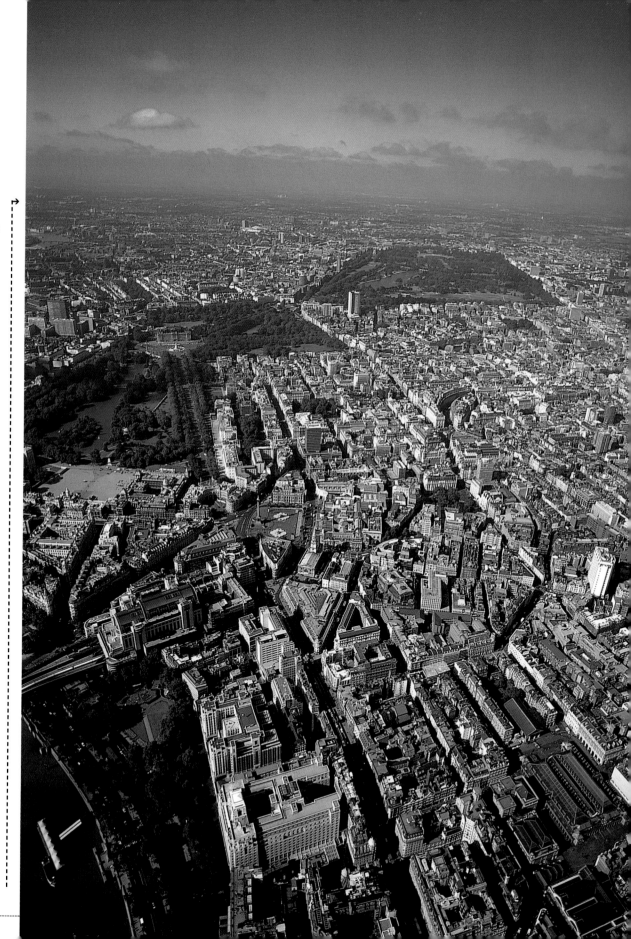

View of London, England

I finish loading the cameras, check the exposure meter, double-check my safety harness, and then confirm the door is locked open. I check that the pilot and I can hear each other okay. I position myself at the edge of the door with one foot on the skid of the helicopter. The twin jet engines roar as they burst into life and we hover-taxi to the pontoon that juts out over the river. A final check with Battersea Control Tower and we start our backwards ascent to around 250ft before the pilot swings out over the River Thames.

In the days leading up to this shoot I have submitted our flight plan with air traffic control to obtain what is known as a 'whisky' number, which, once activated, gave us clearance to our locations over the city.

Climbing quickly for safety we cruise down to the House of Commons, our first location. Hovering 500ft above Big Ben, focusing on a suitable composition, I notice the huge terrace scattered with tables overlooking the Thames where Britain's politicians gather for drinks. And where else but from a helicopter could you see the extraordinary village of buildings on top of Harrod's, 10 Downing Street, or Buckingham Palace, all within the space of ten minutes? Next we cross the river to the London Eye. We hover nearby, which offers us much the same view as the passengers in the Eye's capsules.

I concentrate on the images while also taking in the breathtaking freedom of flying over the city. Rush hour does not exist up here. We can cruise at over 120mph as the whole city unveils itself beneath us.

We circle the Isle of Dogs, and hover 150ft above the pinnacle of Canary Wharf Tower. Beneath us, 45 storeys of window reflect the evening sunlight. Casting its shadow across the East End, the building turns into a huge sundial.

As we fly, the pilot is in constant contact with Heathrow Special or City Airport Control. Occasionally we are asked to make way for a commercial jet coming in to land at City Airport. We see a sleek orange air ambulance whisk beneath us to another life-or-death emergency.

The sun sinks in the sky, bathing the buildings in an orange glow. Soon enough, it is time to head back west along the Thames. We climb up to 1,500ft and speed the short trip back over the countryside to Booker airfield: the end of a fruitful day.

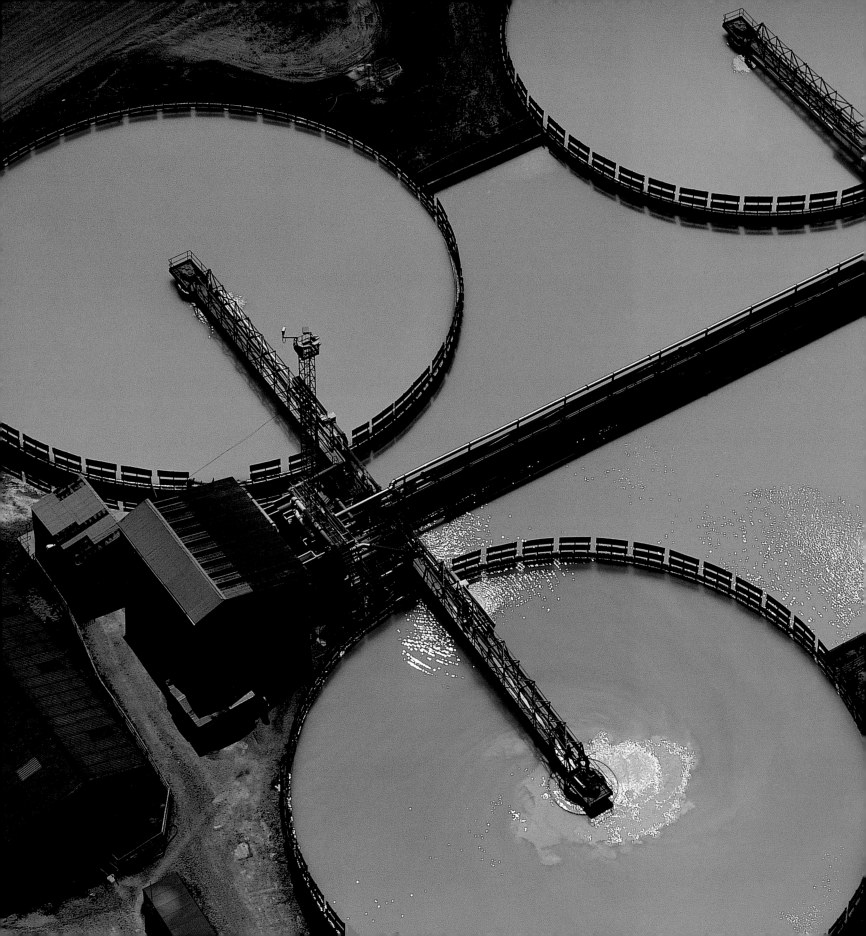

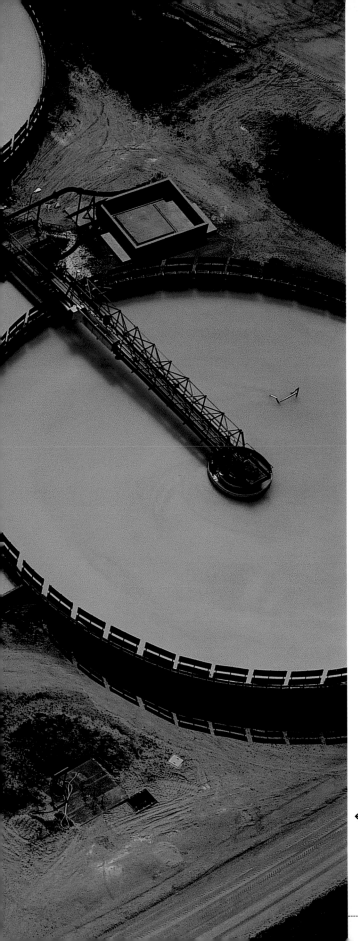

↰ Clay pit mine, Devon, England
It's strange how the most industrial landscapes look beautiful from the air. This one looks like a series of futuristic swimming pools. It was this paradox that struck me as I flew over en route to another location.

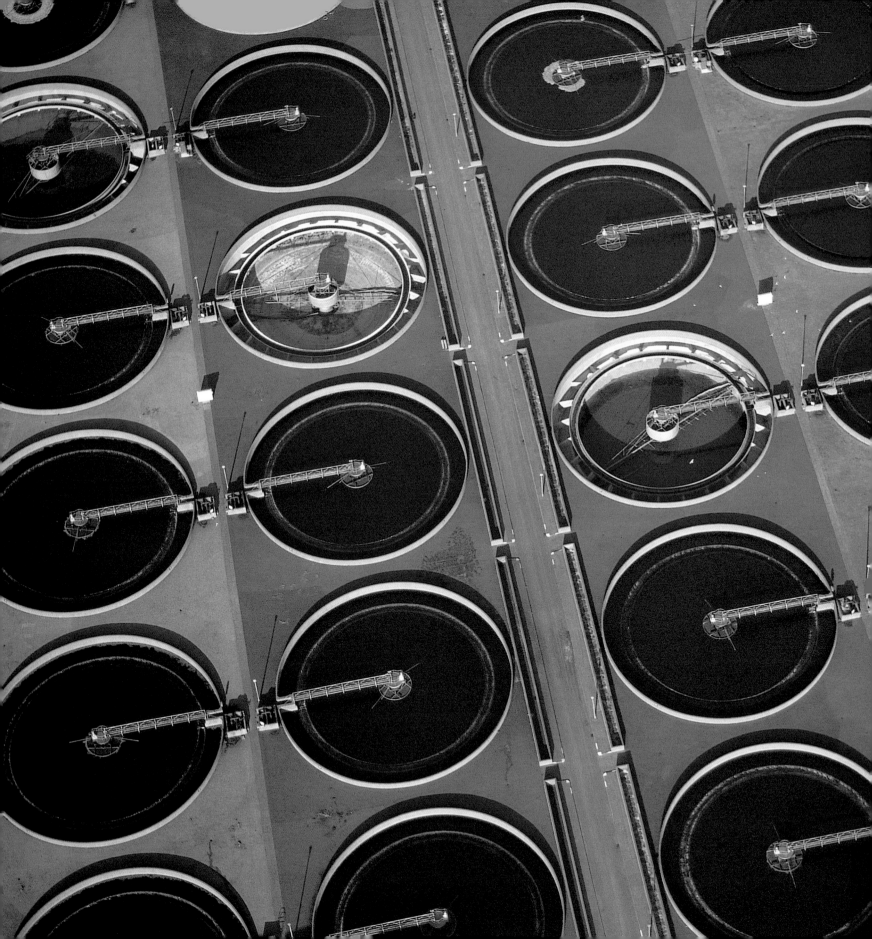

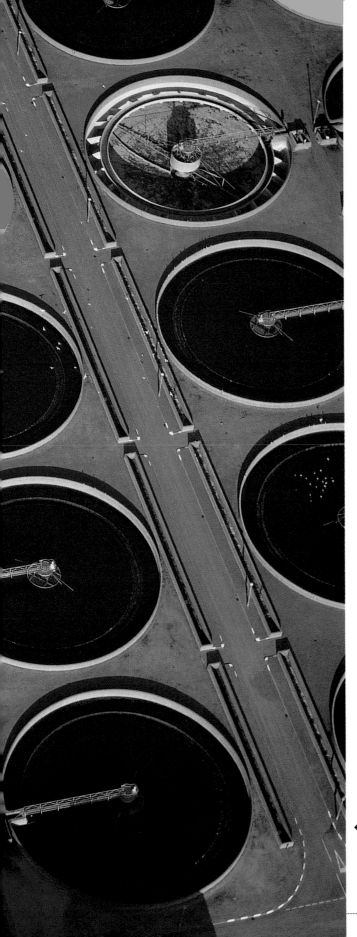

← **Sewage works, east London, England**
This image makes me think of sci-fi movies. That's the thing with aerial images: the perspective is completely different from your everyday experience of a view.

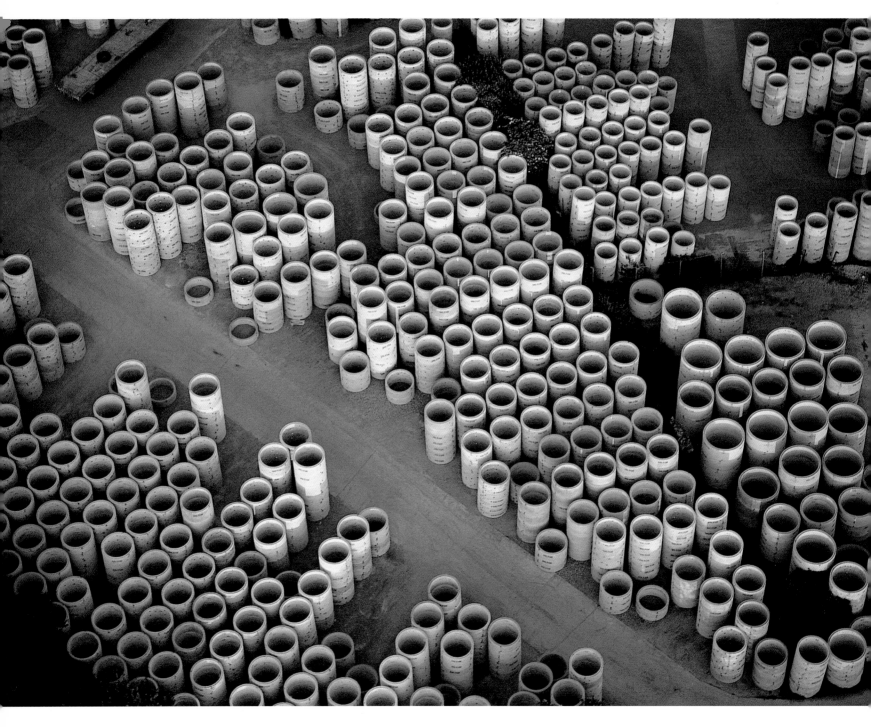

↑ **Pipes in storage**
Resembling a vast, industrial honeycomb,
the repetitive, if chaotic, pattern is compelling.

Terminal supplying underground gas piping

What is most striking about this image is the unexpected color. The image is at odds with what it really is – piping, after all – and looks more like the internal workings of a crazy circuitry board.

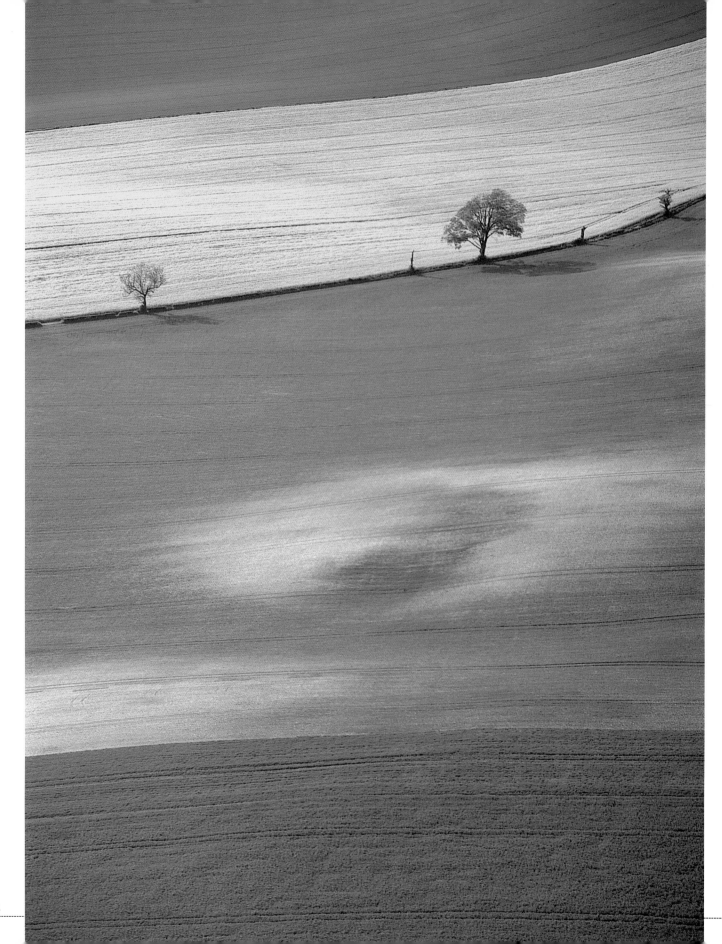

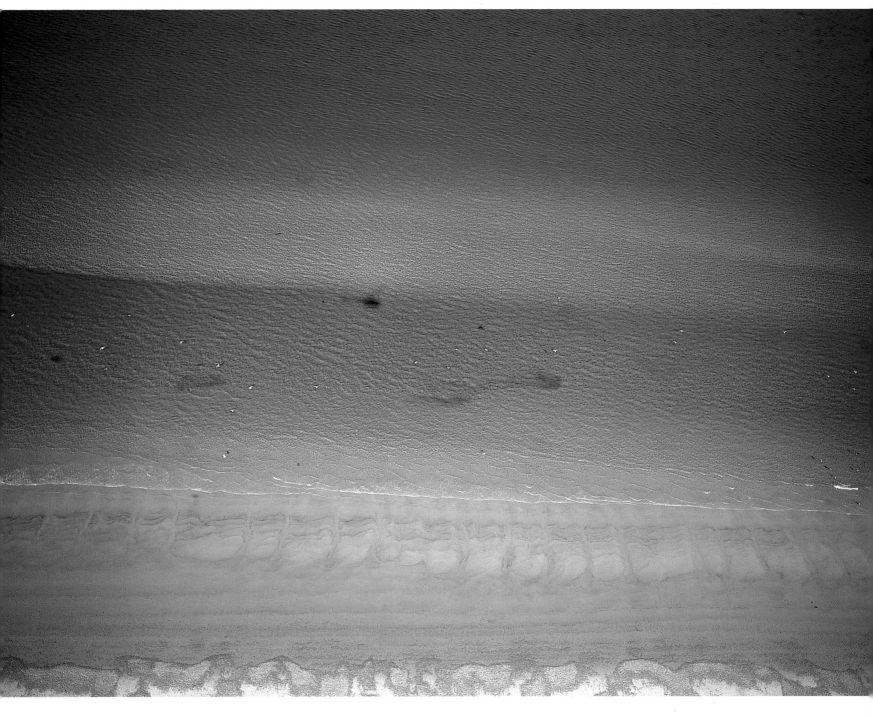

Fields and trees
This is a very simple, but appealing image. The two trees that disrupt the stripes of yellow and green are essential to this image. It would be too graphic without them and they add the extra interest.

↑ **Beach in Scotland**
With aerial photography you normally have to be aware of making sure that the shadow of your aircraft does not get into the shot, but here I purposely cropped it in as I thought it added to the composition. The shadow is of a Robinson 44.

Lough Carra, County Mayo, Ireland *(overleaf)*
Who would believe this is Ireland, it could be the Amazon. For me, this image works best because of the emerging patch of sunlight over the island, highlighting it against the myriad greens of the background.

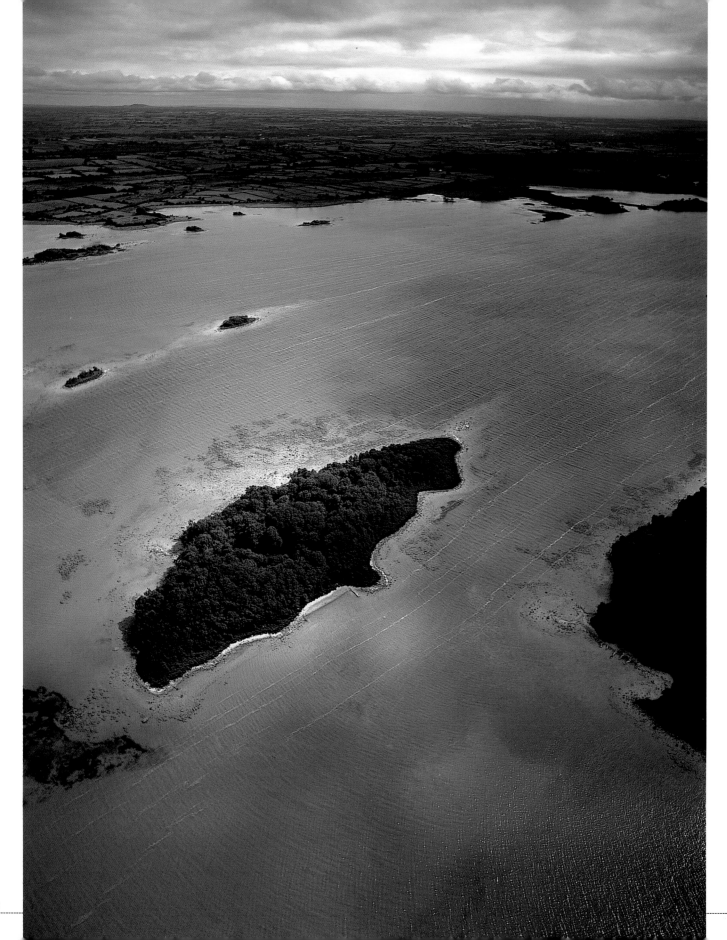

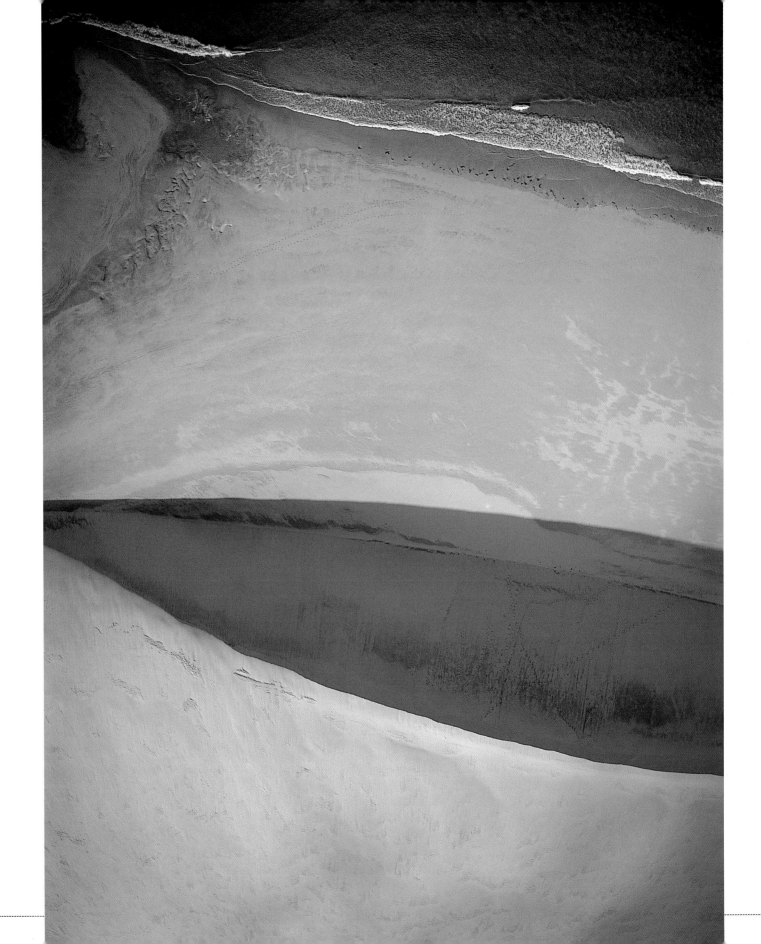

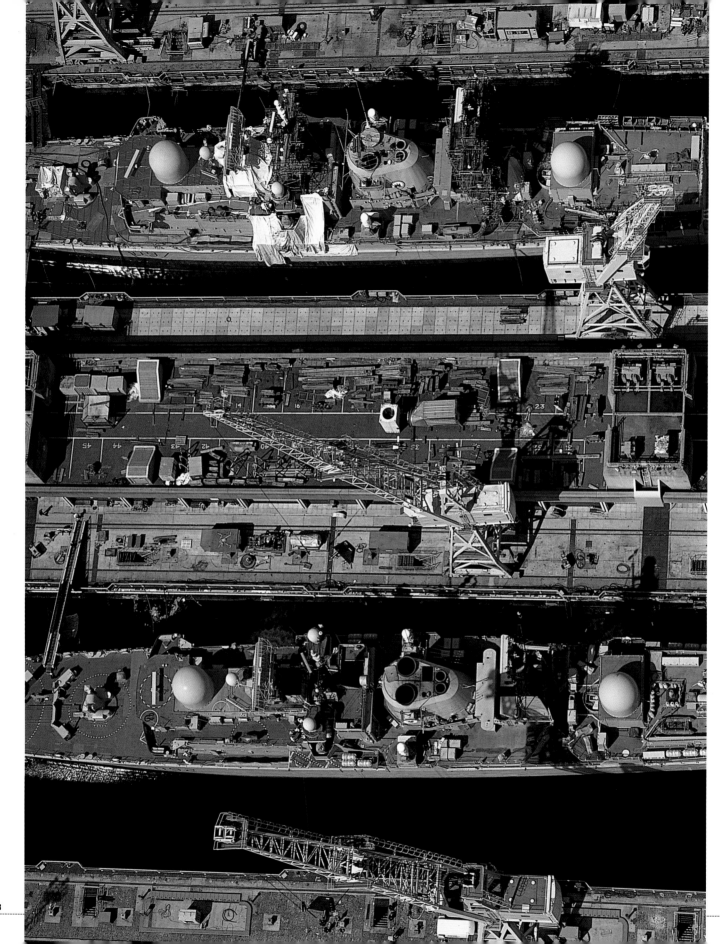

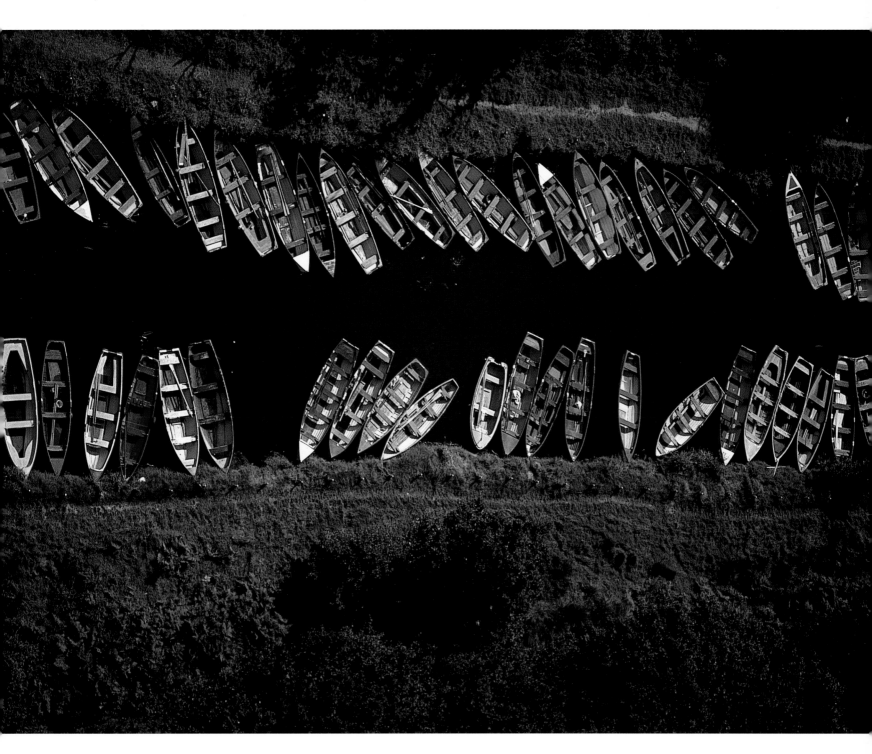

Sand dunes and sea, Scotland *(previous page)*
While refuelling for this shoot at Wick airport on the east coast of Scotland, I met another aerial photographer. He'd flown in from Scandanavia, and was after a few rolls of spare film. Luckily for him I had about 300 rolls of all speeds so I gladly let him have a box or two. That's kinship.

← **Royal Navy Dock Yard, England**
A visually complex image with a great deal of detail crammed in. For me, this is one of those photographs that increases in interest the more you look at it. Every time I see it on a lightbox, I discover something I hadn't seen before.

↑ **Rowing boats, Ireland**
Small, non-commercial airports are rare in Ireland and refuelling can be difficult, so when I shot this image we had to plan the flight carefully. I stumbled upon this image after photographing one of the great lakes; it is something I love to see when flying.

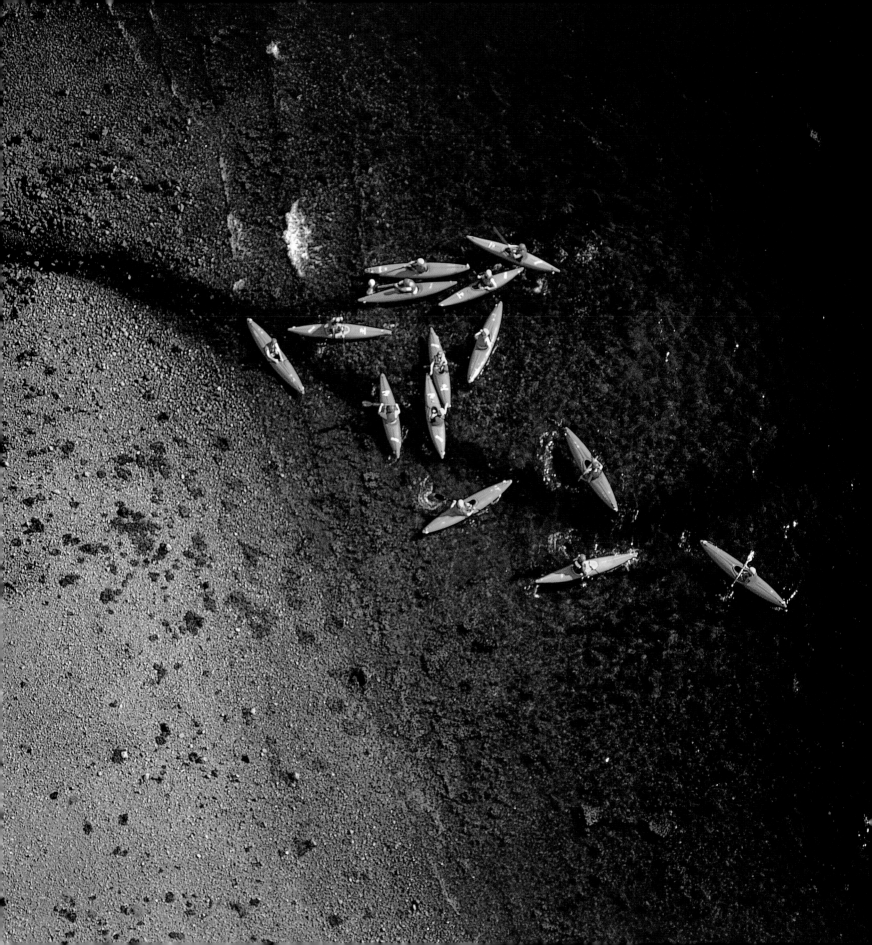

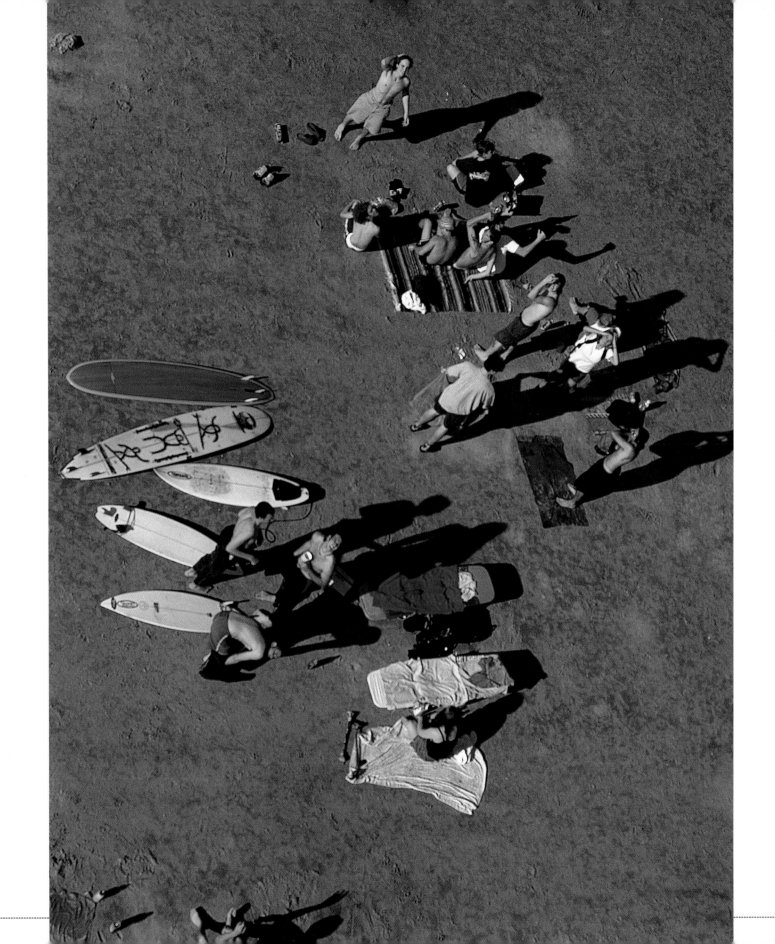

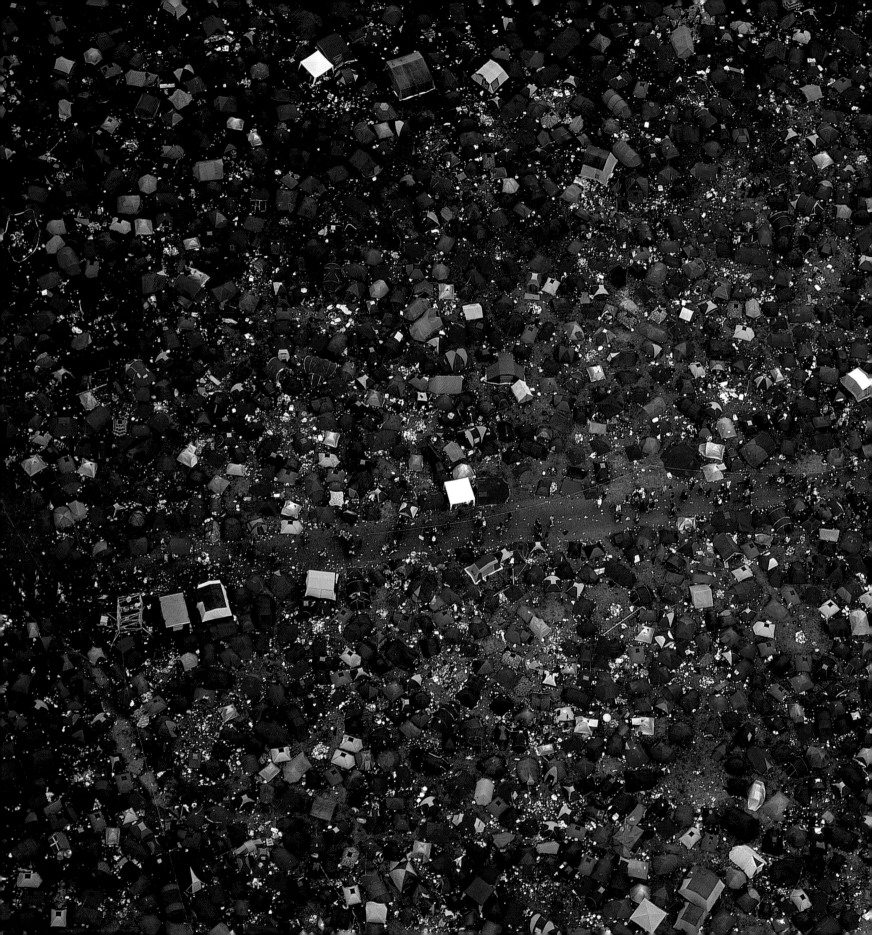

↑ Canoeists, Scotland *(previous page)*
These canoeists make a striking image: slivers of red on an almost black background. Again this was one of those unexpected, incidental shots that I enjoy coming across now and then.

↑ Surfers on a beach *(previous page)*
You know how it is if you're on a boat on a river and people wave to each other for no apparent reason - well, it's the same in a helicopter. Why? I really could not say, but you get waved at all the time. I once flew past Glastonbury Tor, a tiny hill in the middle of Wiltshire, England. Rising out of a huge plain, it has fantastic views for miles around. I flew right past it on a lovely weekend in the summer when there were a hundred or so people who had walked up it to admire the view. We circled a couple of times taking some photographs and then as we were about to leave I waved back to a couple who were waving at me. Everybody on the hill waved back, and for a brief second I knew what it must be like to be a famous musician on stage at a rock concert.

← Tents at Reading Festival, England
In August every year, thousands of people flock to Reading for one of England's most famous music festivals. One year I was flying back from Scotland and decided to make a small diversion as I knew the festival was in full swing. I think this image manages to capture the chaos and sociability of the festival as well as the hazards of remembering where you pitched your tent! The image was later sold for use on an Iron Maiden CD cover.

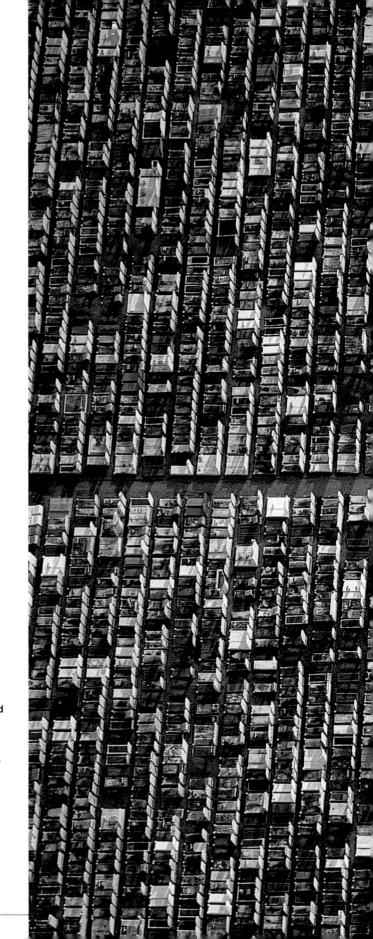

↱ **East Ham Jewish Cemetery, London, England**
*I didn't know this cemetery existed until I flew
over it while working on 'London from the Air'.
With a first look at the photograph, it is difficult
to know what you are looking at, but with closer
study, the image becomes more complex; for
example, the plentiful symbolism in the way the
path crosses over in the middle.*

*Eight years after I first flew over the cemetery,
I had to revisit to get an up-to-date photograph
for 'London: Then and Now'. By this time I had
seen a picture taken of the site in 1921 when it
was almost completely devoid of gravestones.
The contrast really makes you stop and think.*

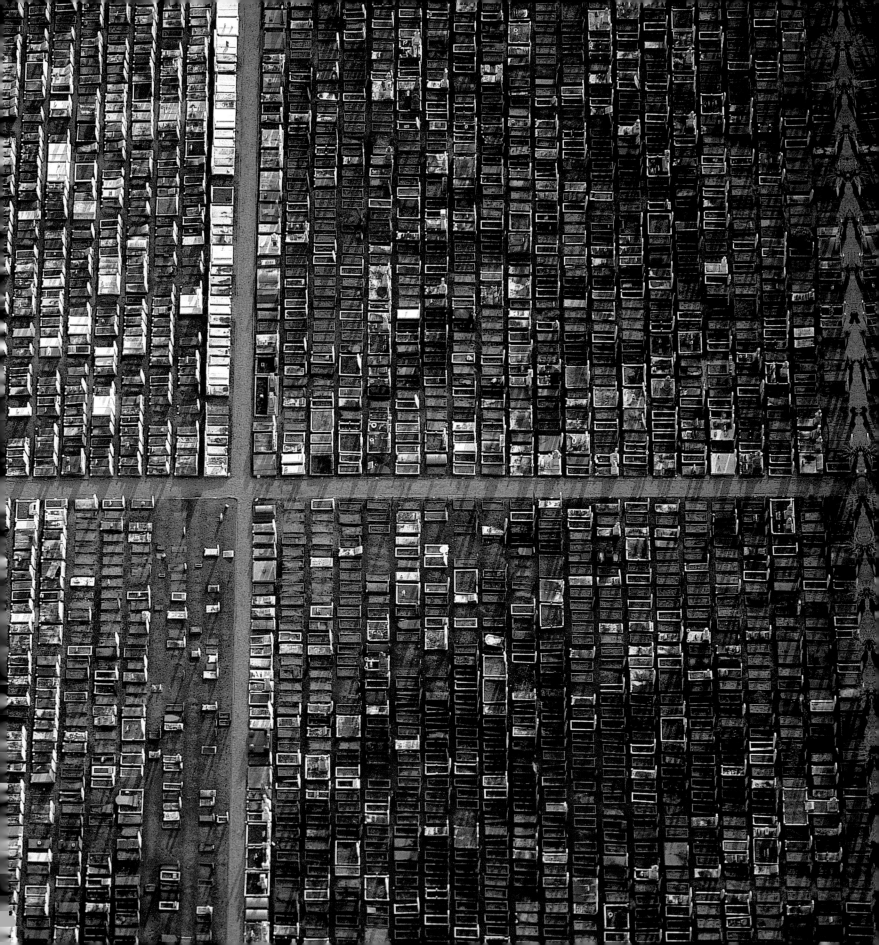

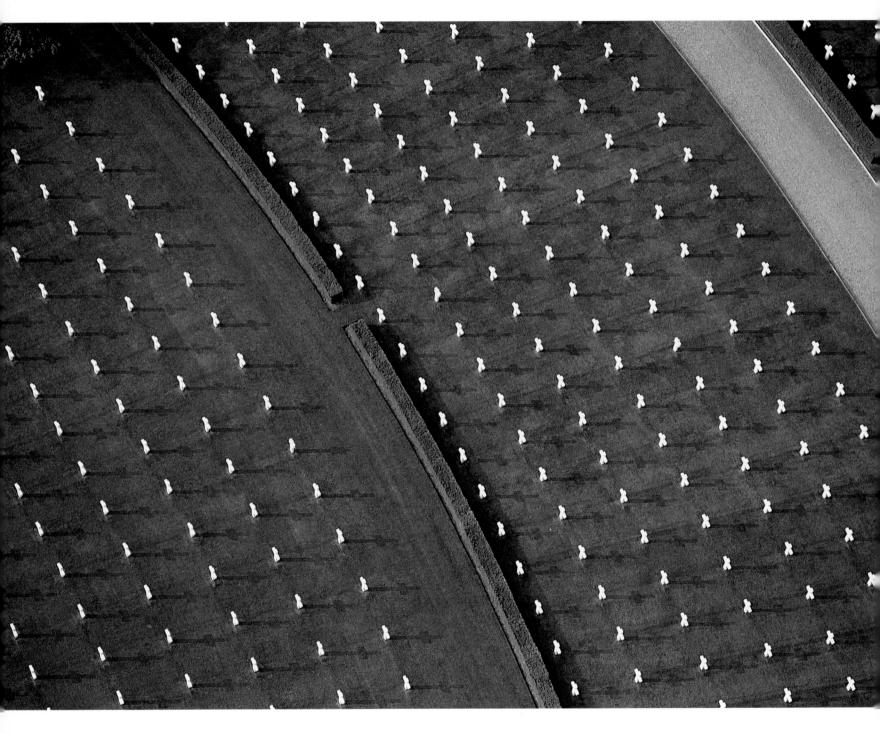

↑ **American War Cemetery, Cambridgeshire, England**
This is another 'found' image that I saw flying back to base from a shoot of Cambridge. The white crosses, each representing one life, cast graphic shadows across the grass.

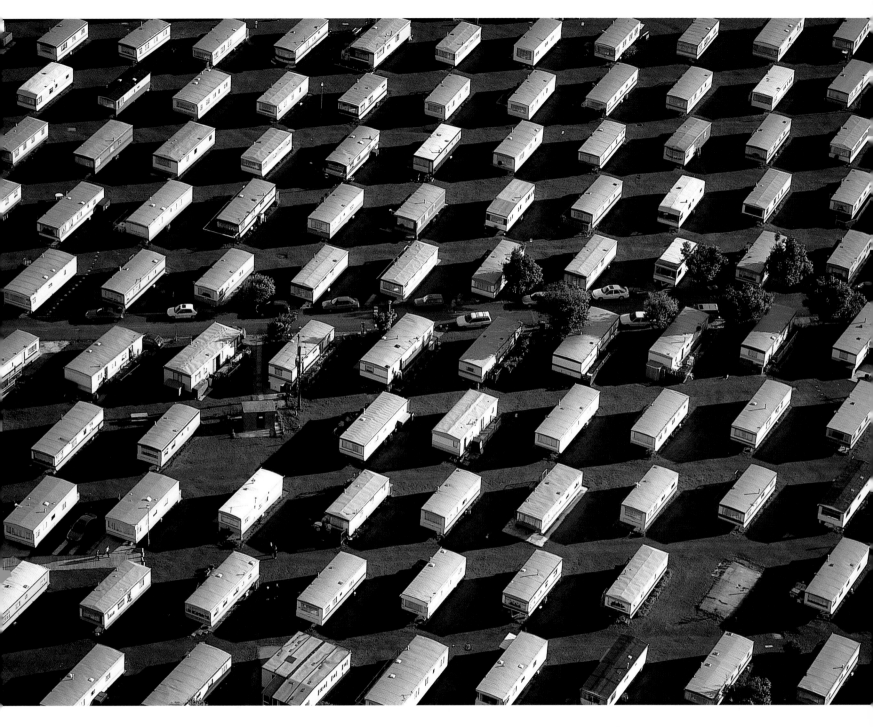

↑ **Caravan site**
*The way that some aerial images work together
can be very revealing. The similarity of pattern
and color of this caravan site makes for an
uncanny relationship with the war cemetery (left).*

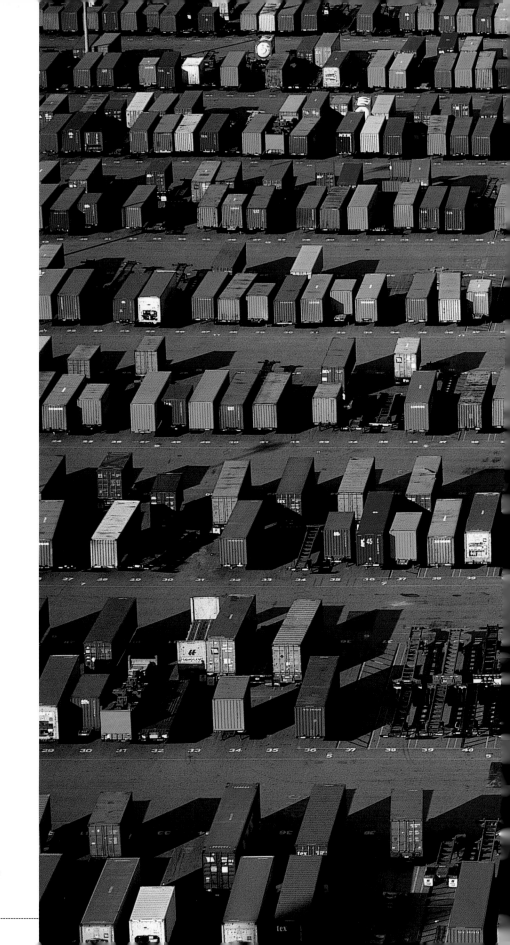

→ **Container port, Savannah, USA**
*At the risk of being accused a container junkie,
I include this one. I like the simplicity of the line
and color here.*

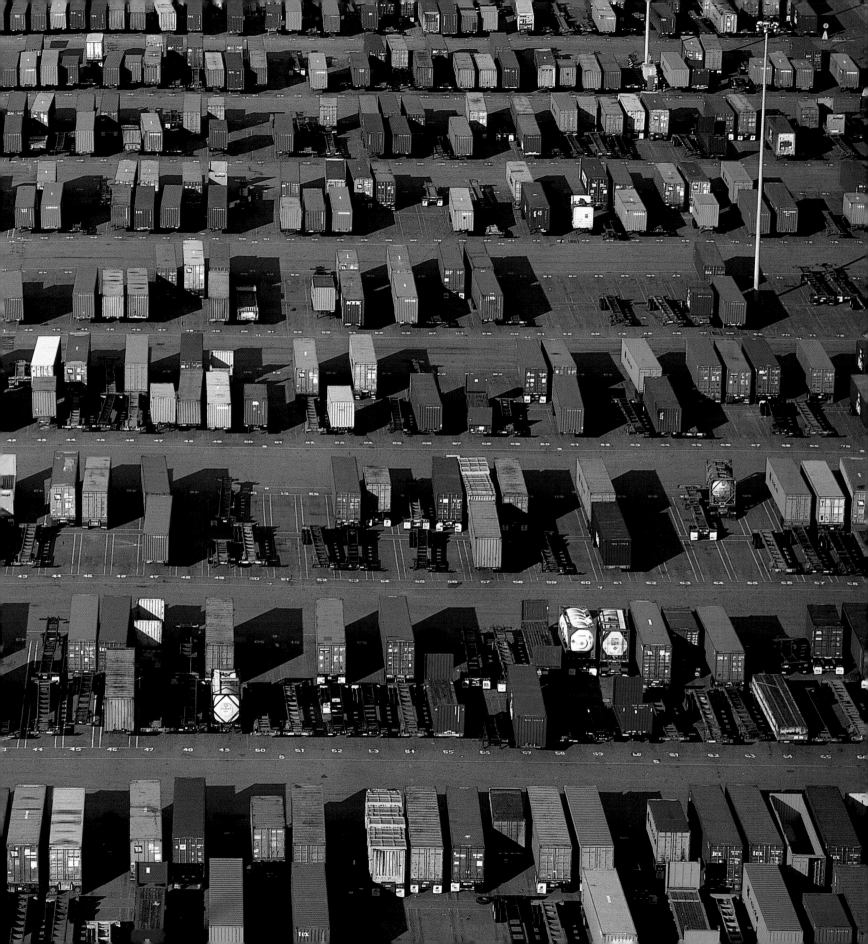

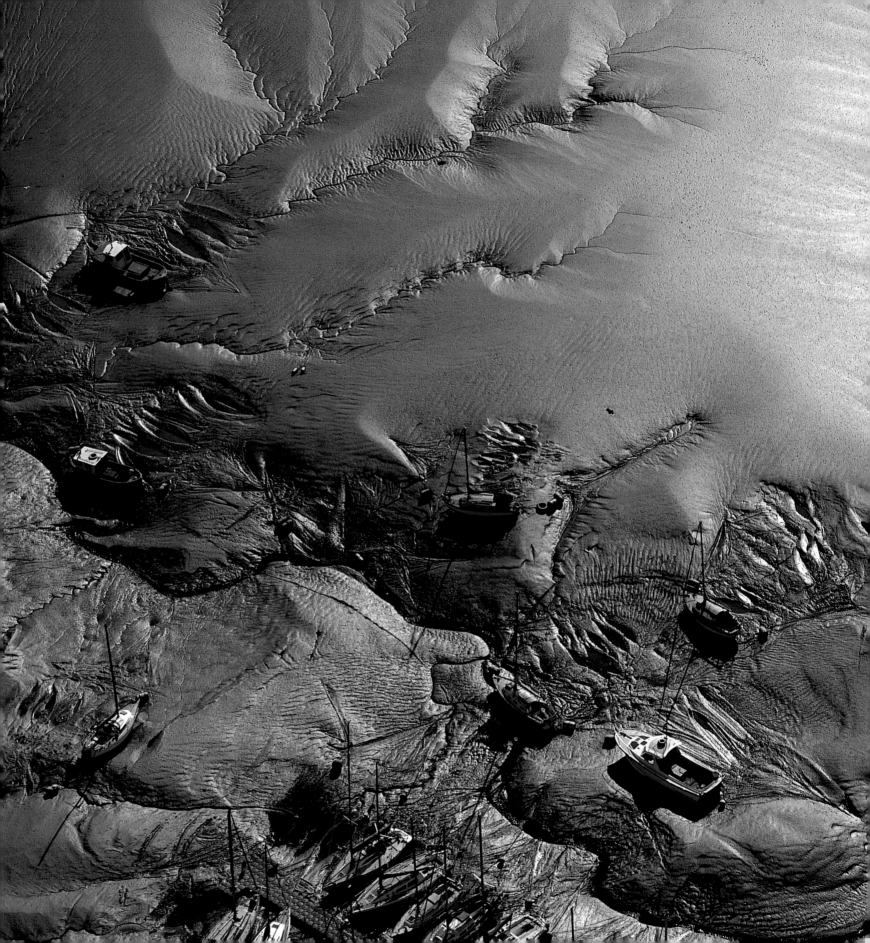

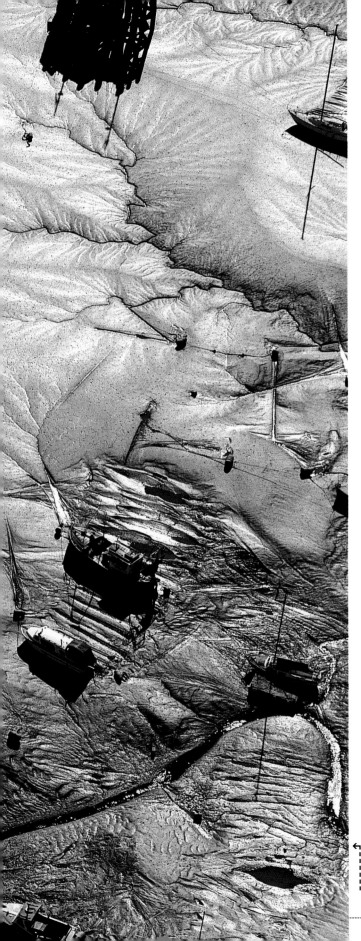

Boats on mud flats
I'm fascinated by the way the light on the surface of the mud flats creates a strangely puckered 'deflated balloon' texture.

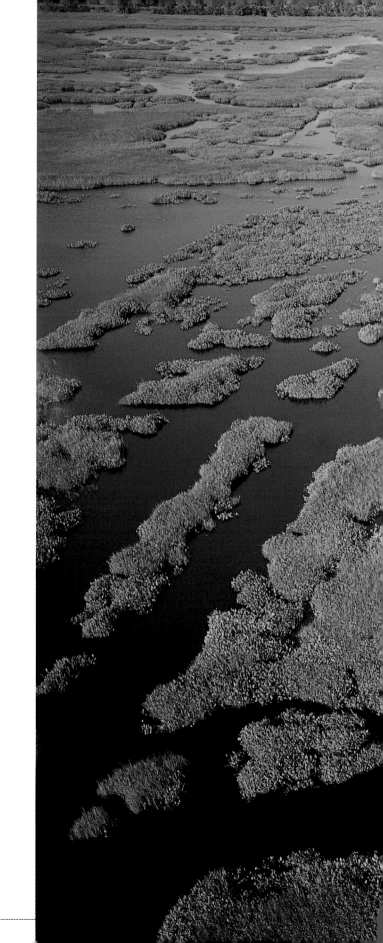

→ **Flooded cotton fields, USA**
*This is a characteristic image of this region.
From the ground you would not get anything
like the same impression of the relationship of
water to land as you do here.*

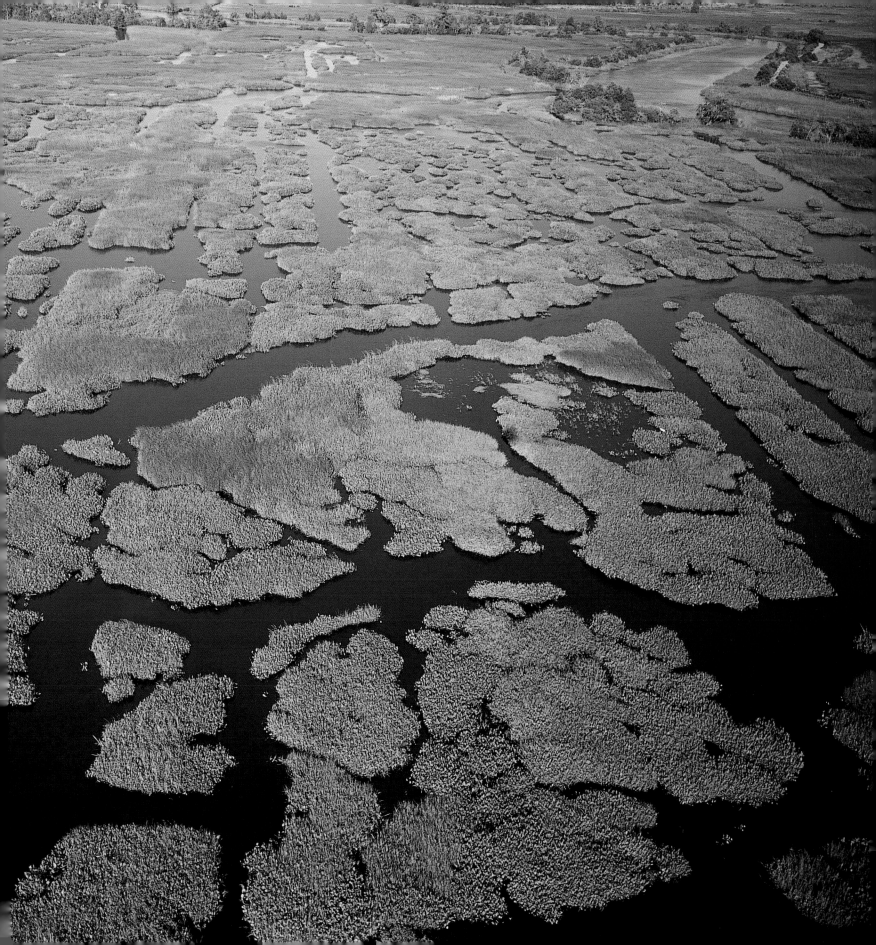

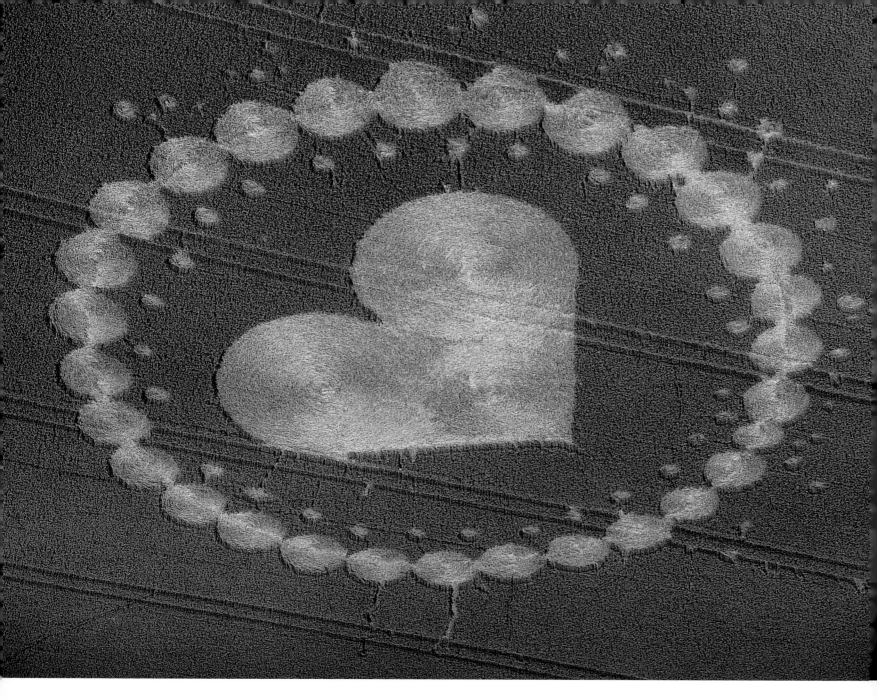

↑ **Heart-shaped crop circle**
*I'm sure this crop circle (or rather, heart) gives
ammunition to the crop circle skeptics, but it was
an irresistible image, and I couldn't let it go.*

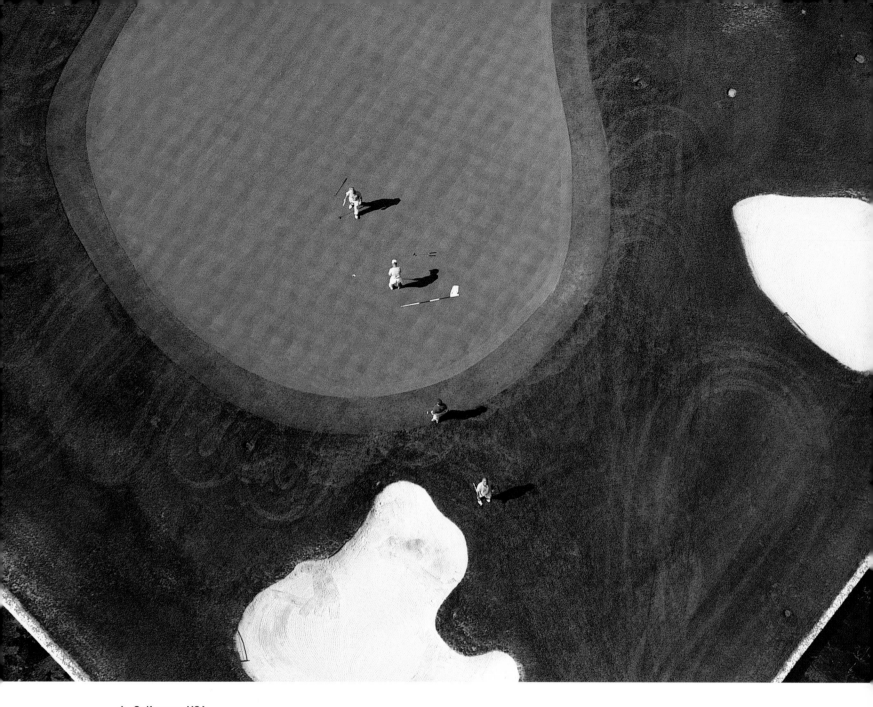

↑ **Golf green, USA**
The strength of this image lies in the hue of
the colors and the textures of the grass.
The inclusion of the golf players gives a sense
of dimension and scale to the photograph,
and the dark shadows highlight their actions
which adds interest.

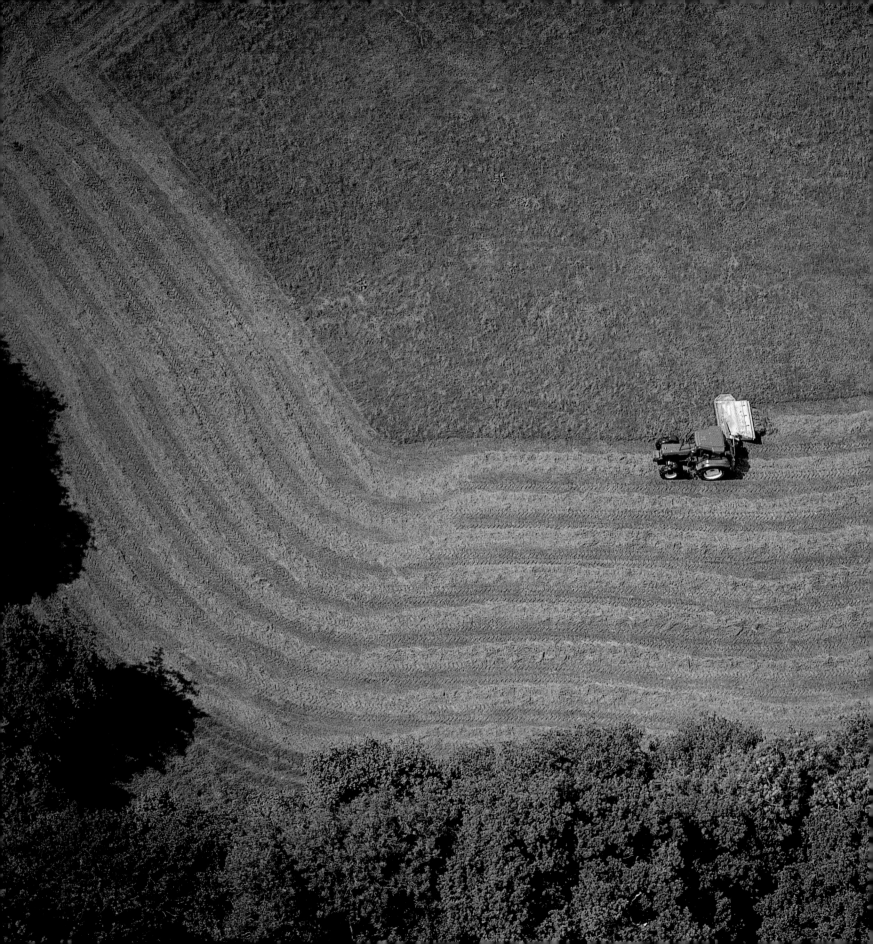

Grass-cutting
This is another simple image, a picture taken of a mundane, everyday rural activity. But from the air, the patterns it makes take it to another level.

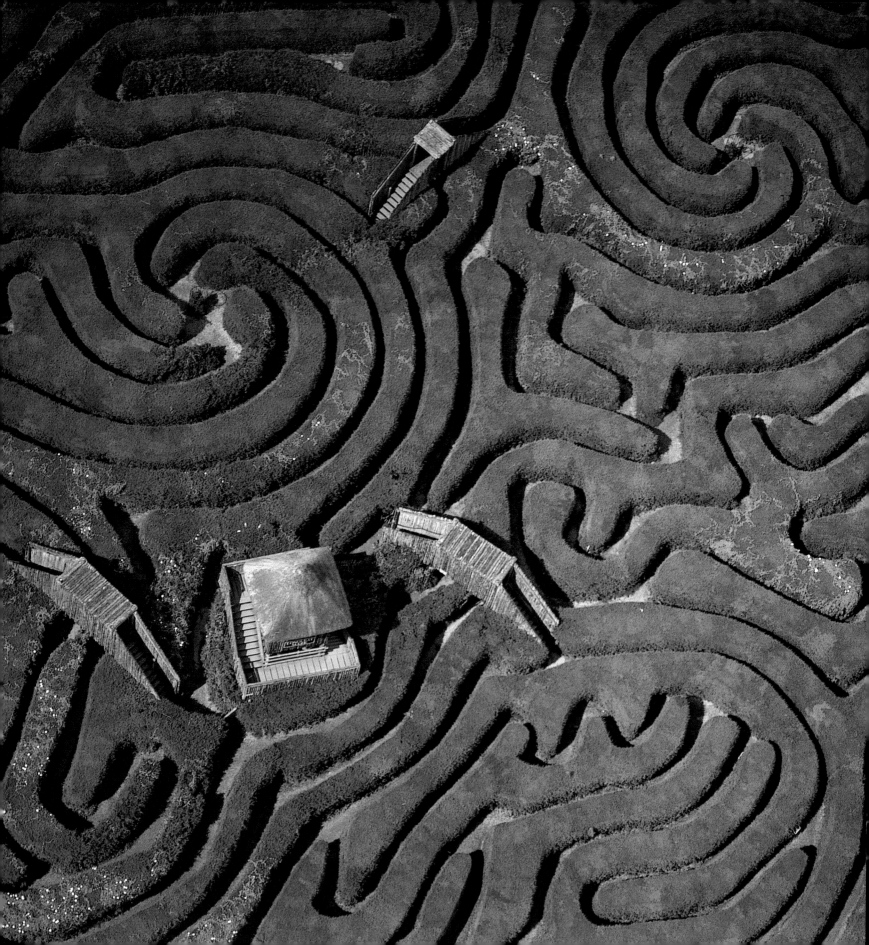

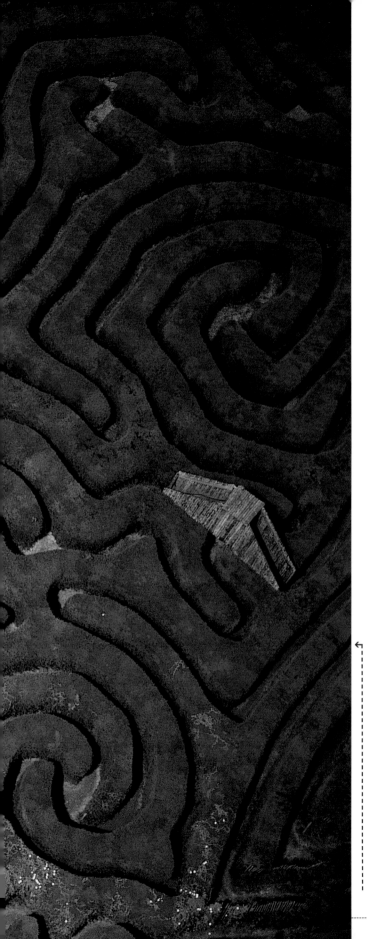

Maze at Longleat, Wiltshire, England

I love this image. It's simple and graphic and gives a great perspective on this giant puzzle. Flying regulations are pretty strict over places with people so this was shot with a long lens plus a 2x teleconverter. It took a few passes to get exactly into position for what is quite a small subject shot from the air. This is when it becomes important to try and build up a relationship with one particular pilot, who knows instinctively where you want to be placed. Mazes are a popular advertising choice as they can be used to symbolize emotions such as confusion, and ideas such as 'lost' and 'found'. Sometimes images need to be 'cleaned up', and by using Photoshop superfluous objects can be removed. I have used this technique in alternative versions of this photograph, taking out the bridges with the cloning tool to create a simpler image.

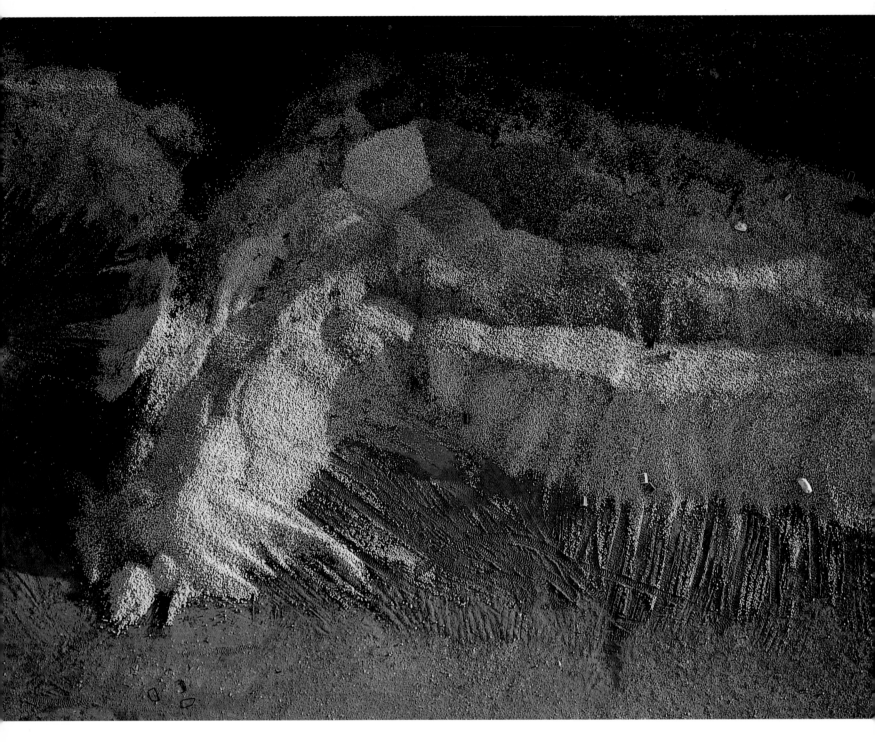

↑ **Tomatoes, France**

Occasionally I fly over something, and think, 'What on earth is that?'. This thought went through my head when I saw this, on the back of the Rhône in France. Still, I thought it made a great image so we circled it while I ran off half a film. The image was to appear in a book so I showed it to a few people to find out what it was.

It turned out to be tomatoes! Apparently the EEC (European Economic Community) subsidizes farmers to grow them but it is not economically viable to get them to market. Hence truckloads are dumped here and later in the winter when the river rises the water sweeps them away out to sea.

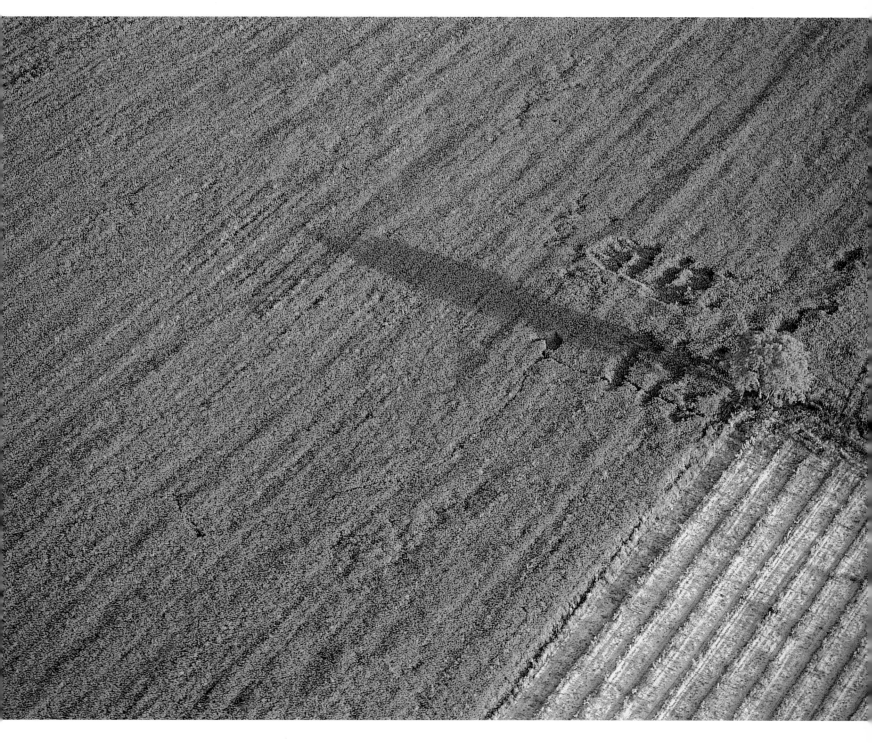

↑ **Poppy field, Provence, France**

I was lucky enough to get a commission to produce a book on Provence with author Peter Mayle, who had become famous for his bestseller 'A Year In Provence'. The publishers gave me carte blanche to bring back any images I liked, and much of the book is filled with patterns of color such as this poppy field. I spent three *months working on the book flying a tiny two-seater R22 from England. We shot the book in the height of summer and rose before the sun came up and all the shadows and details of the landscape were lost. Therefore my working day consisted of getting up at 5.30am, flying between 6 and 9am, back to our villa for breakfast, develop* *the film in Avignon before lunch, lie all afternoon by the pool, and then take off again for another flight around 5.45pm. It was a great job while it lasted and, needless to say, I have been trying to source a similar commission ever since.*

↑ **Fleet of red cars, Oxfordshire, England**
In the environs of Oxfordshire there are a number of disused World War II air hangars that now house transport of a very different kind. As the car-manufacturing plants of Europe churn out more and more vehicles, somewhere has to be found to house them – and this is it. Thousand upon thousand of cars, vans and 4x4s are contained here awaiting shipment to showrooms. They are not normally parked in such a uniform fashion. However, these vans are not only all the same color but parked with such precision you would imagine that the image was the result of a lot of post-production work in Photoshop. In reality this is exactly how they looked.

↑ **Waterloo Station in snow, London, England**
I like this image because it's almost impossible to know what you are looking at or the scale. It's not that often that it snows in London, and even less often that the snow settles long enough to book up a helicopter and get up over the city. The day I shot this was particularly cold. I remember that even though I was wrapped up in several layers, and used my usual trick of keeping an external battery pack down my pants with the lead plugged into the motordrive of my camera, after a couple of hours I was finding it increasingly difficult to load and unload the film into the camera's 220 back.

↑ **Greenhouses**
*I can't resist adding this image of greenhouse
roofs to this triptych of red, white and blue – it
just works so well. I don't remember the location
of this shot, but it fits beautifully.*

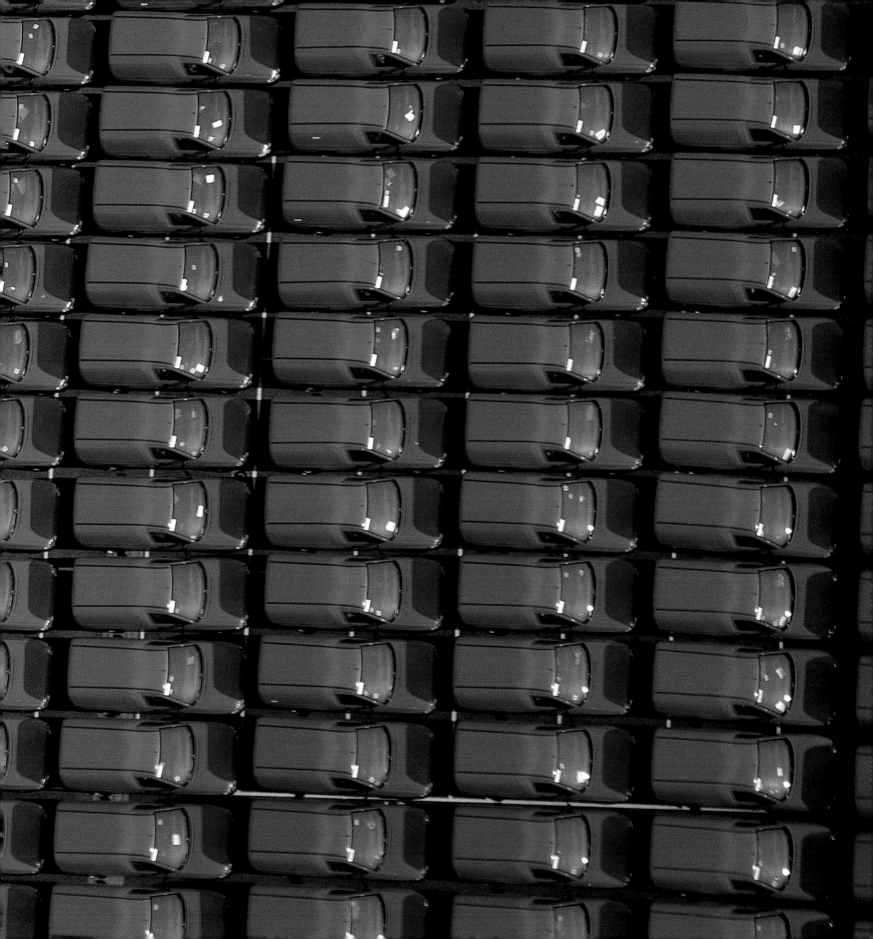

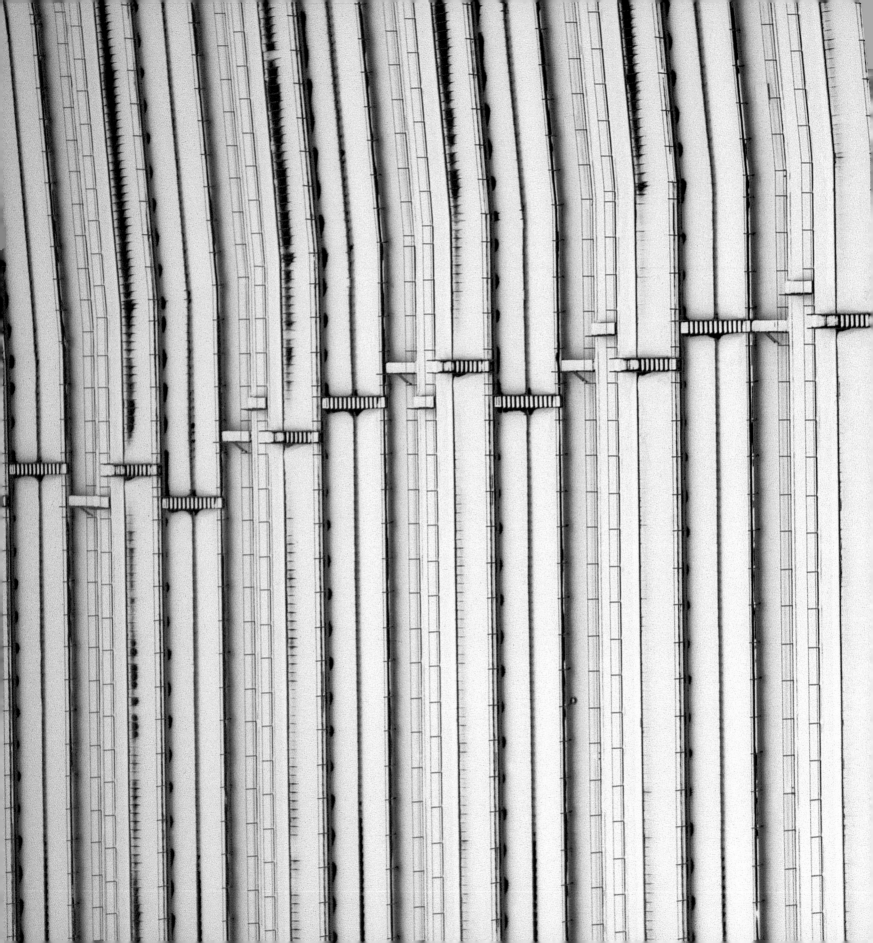

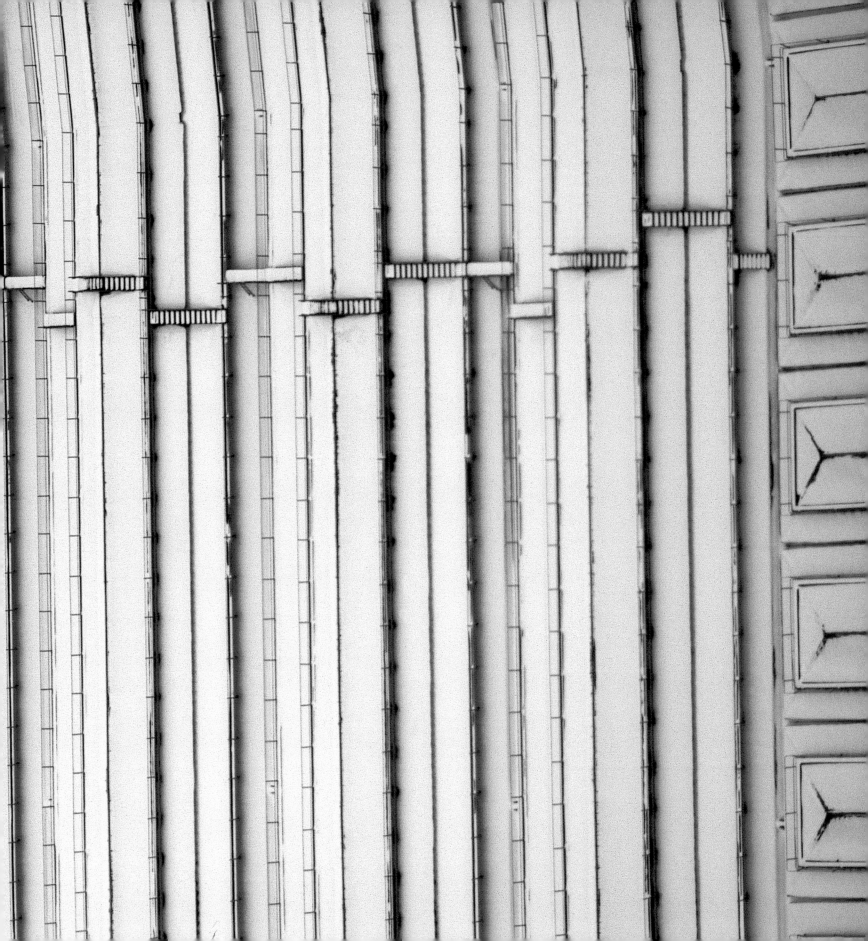

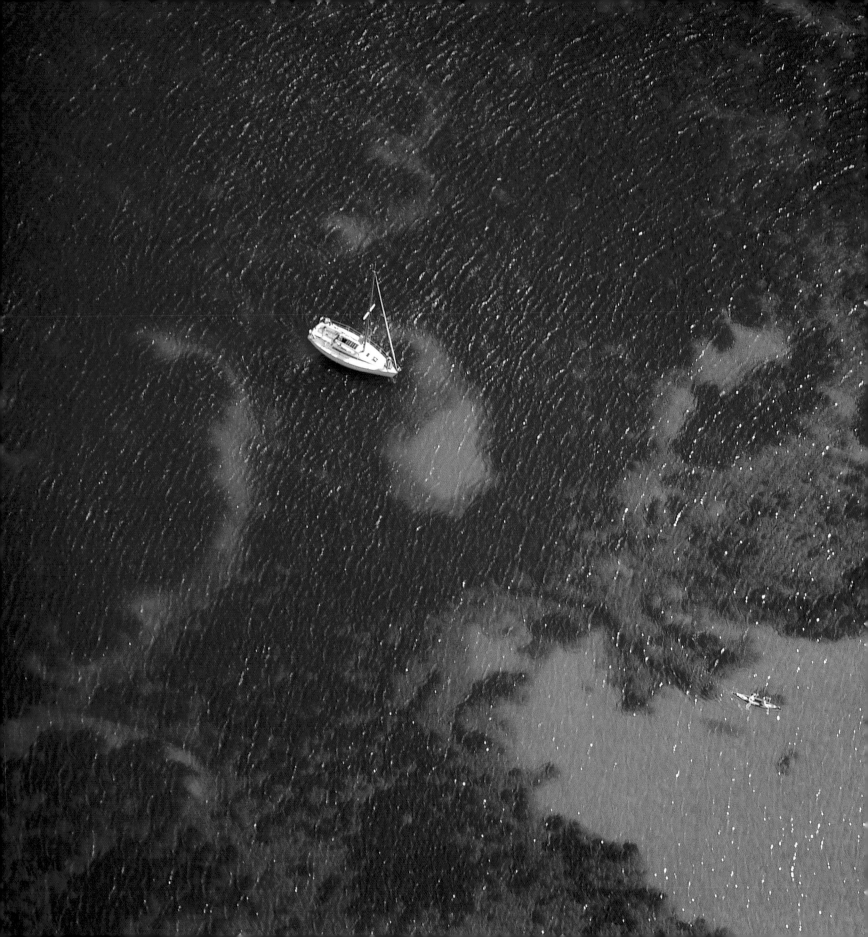

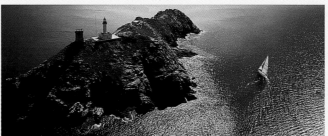

A desolate islet off the coast of Corsica, La Giraglia provides the name for one of the definitive regattas in the Mediterranean. The 243 miles out around the lighthouse and back to the mainland provide a classic test of the yachtsman's skills: preparation, tactics, pinpoint navigation... And, of course, superlative timing.

ROLEX
of Geneva

LA GIRAGLIA.
43 DEGREES 1 MINUTE 36 SECONDS NORTH.
9 DEGREES 24 MINUTES 24 SECONDS EAST.

AND EVERY SECOND COUNTS.

Rolex press ad
Agency: JWT

Shot off the northern tip of Corsica, this shoot had more than its fair share of mishaps. Rolex sponsors a boat race every year and wanted an aerial view of two boats rounding the Isle of Giralle for a press campaign. We had hired in two racing yachts to sail down from Cannes especially for the shoot. I flew out to Corsica in March, having previously arranged a helicopter and pilot to be on standby over a three-day period. The day I arrived on the island everything looked set for an incident-free shoot. I went to meet up with the pilot to ensure everything was in order. I checked the forecast and the following day promised good strong winds and clear blue skies. I called the boats and asked them to sail down overnight.

The next day dawned with perfect weather for the shoot and so I went to wait at the helipad for news that the yachts were on their way. The hours passed and I finally received a telephone call to let me know that, far from arriving in Corsica, the two boats were limping their way back to Cannes having crashed into each other! After that, a run of bad weather sabotaged the shoot day after day until, finally, a week later, and with the client's quickly depleting patience, we managed the shoot with just one yacht and a little wind. Fortunately, both agency and client were pleased with the final shot.

The best part of that job was on the return flight to the airport: flying out from the warmth of the beaches up over the still snow-covered mountains. After photographing the yacht we headed back at about 20ft above the surface of the sea towards the shore. At around 130mph it's a real buzz to do this, but I began to wonder why the pilot was not beginning his climb as I assumed we would head back over the mountains. He turned around to me and Karin, the account handler, and said he had something to show us. As we reached the cliff edge we could see a narrow ravine running inland with 100ft cliffs on either side and a small river running along the bottom. In we flew and it took my breath away. Banking around tight corners with little room for error, we saw our first waterfall. The pilot put us into a hover and then we rose vertically 50ft or so up the face of the waterfall to a pool at the top. We flew down each rock valley repeating this until after a few minutes we reached the last waterfall and the top of a mountain. It was the most exciting flying I had done, and as it was Karin's first-ever flight in a helicopter I wanted to tell her not to bother again, as she could only be disappointed after such an experience.

↰ **Yacht, Mediterranean Sea**
I shot this just off the coast of France, near Cannes. The blue hues of the sea, sparkling in the light, are just mesmerizing.

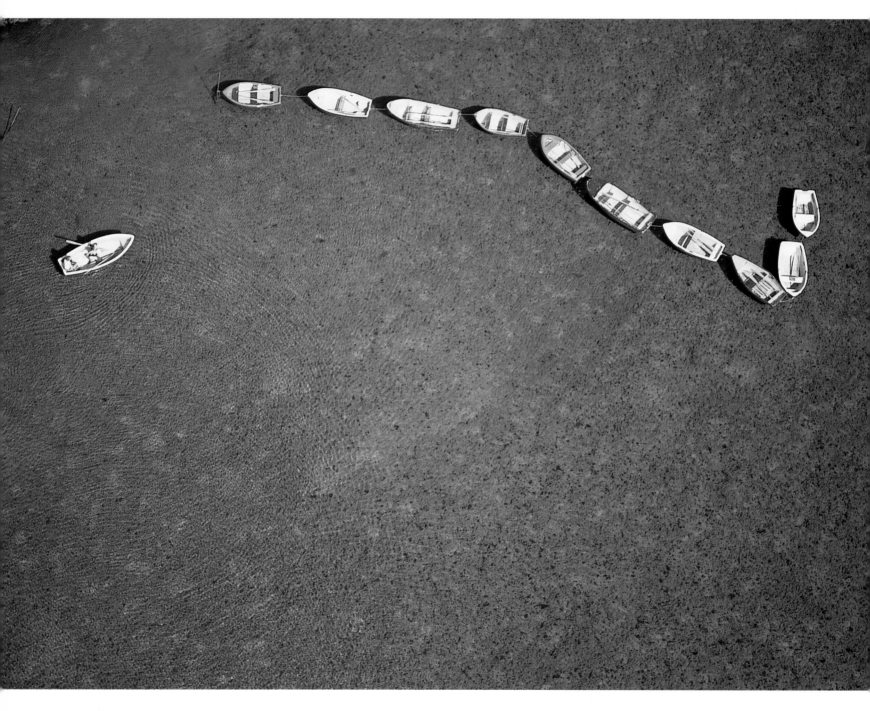

↑ Boat on lake, Arundel, West Sussex, England

For a book called 'Historic Britain From The Air', I was on the south coast of England photographing Arundel Castle. The castle itself is impressive and overlooks the pretty historic town.

Whenever I need to reload film I fly a couple of miles off to cut down on intrusive helicopter noise; when you perform tight circles over a location the noise envelope multiplies considerably. This is how I came across this

serene view of families taking out rowing boats on a lake. I have been criticized by some who say that I include too many abstract images in my work. I suppose this might be valid, but I think it's a shame not to include these small locations, and a disservice to the area I was photographing to leave them out.

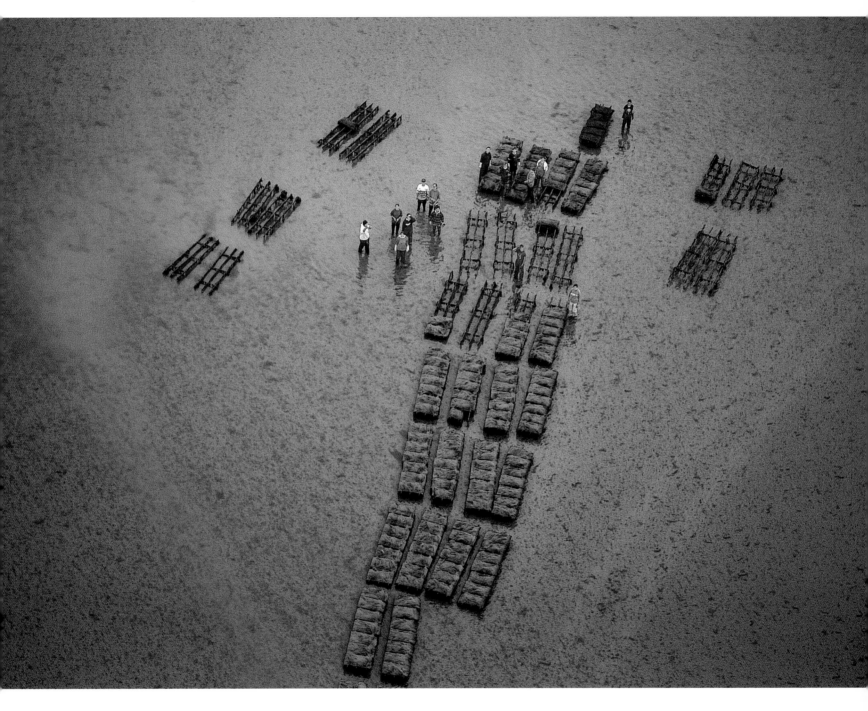

↑ **Seaweed collecting, County Waterford, Ireland**
*This isn't something you come across every day.
There is real curiosity value with this shot, a bit
like the tomato mountain. Seaweed collecting
has a long history in Ireland, and much of the
end product will be destined for the dinner table.*

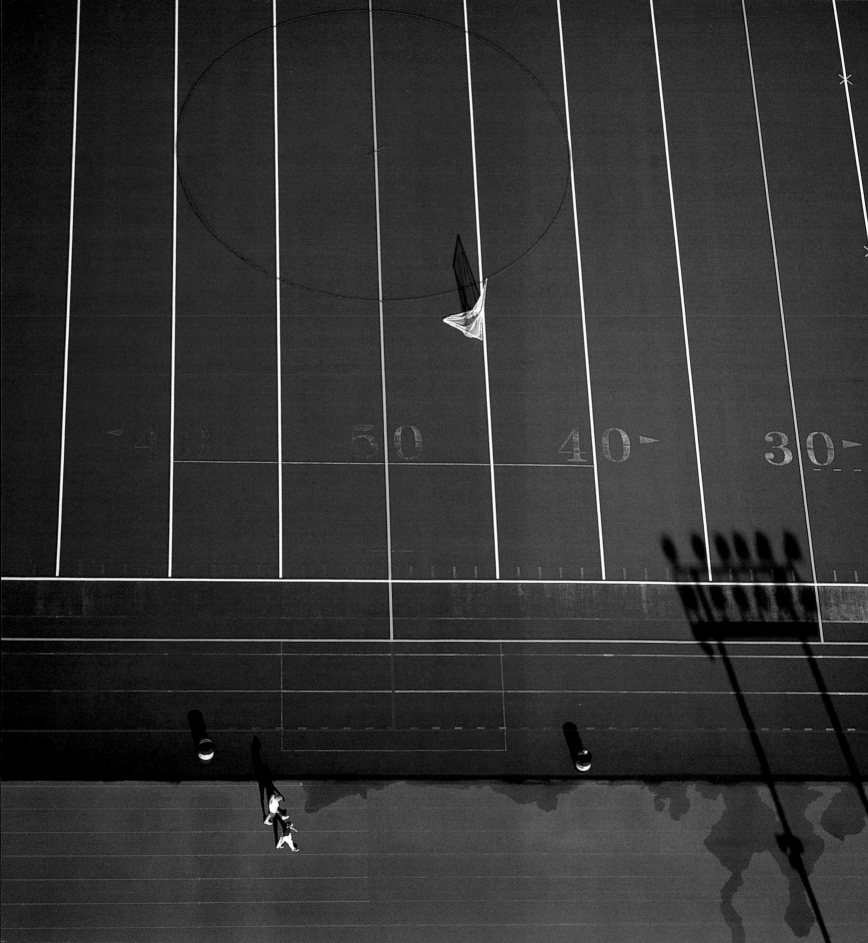

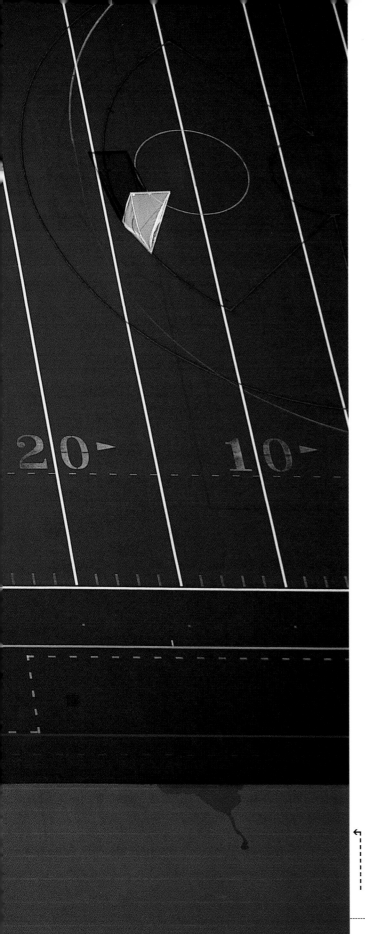

← **Running track, Washington DC, USA**
This shot goes beyond even the description of 'graphic' – it is literally a grid. From above you can clearly see the markings out of the pitch for American football.

The Awakening, Washington DC, USA

Sculpted by J. Seward Johnson in 1980 and situated at Hains Point in East Potomac Park, Washington DC. This is a fantastic sculpture which I photographed a few years ago. Strangely it does not seem to be that well known, and finding information about it, even who had made it, proved difficult.

Cyclists on the beach, Hilton Head, USA
(overleaf)
In the 1950s Charles Fraser developed the idea of a gated community on Hilton Head Island. His vision was to create a resort that would preserve and revel in the island's natural beauty. The result is a pretty extraordinary residential community, full of the very best sporting and golf facilities. It is immaculately groomed, and so stylized that it is almost like a Disney theme park. There is a stretch of homes along the beach front that are simply breathtaking, all built with lavish pools sweeping around the house. I expect it's an incredible, if slightly artificial, place to live. The 'gated' part means just that: as you drive onto the island you are checked by security at the gates to the community.

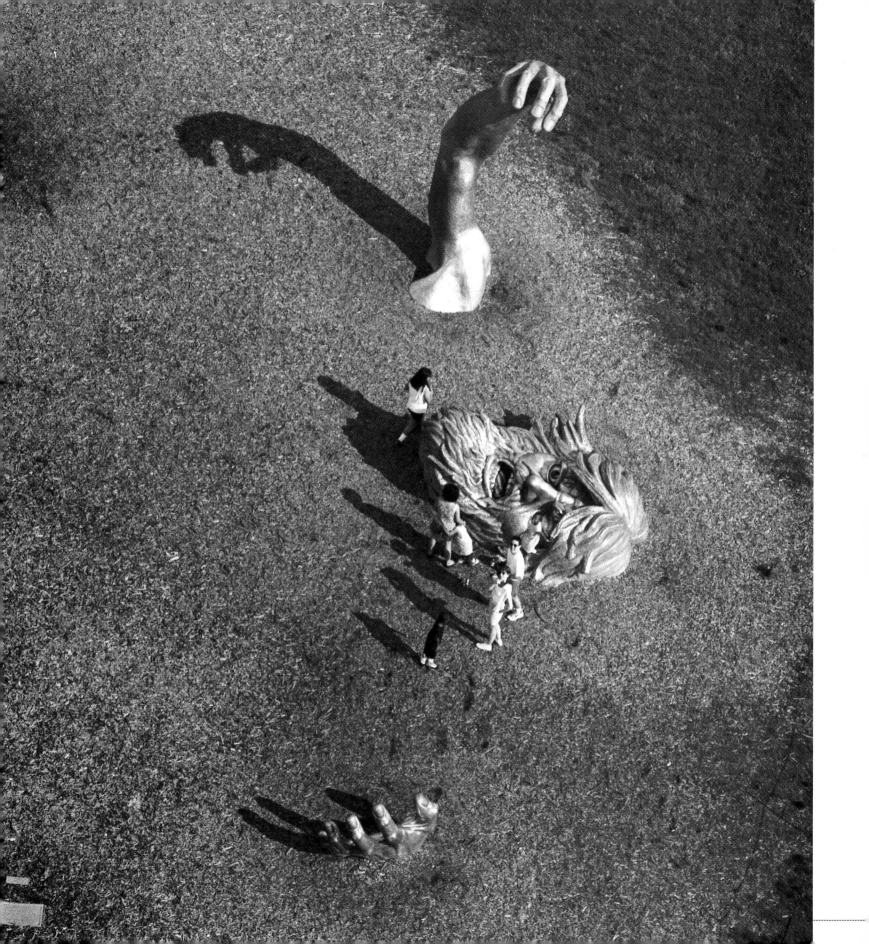

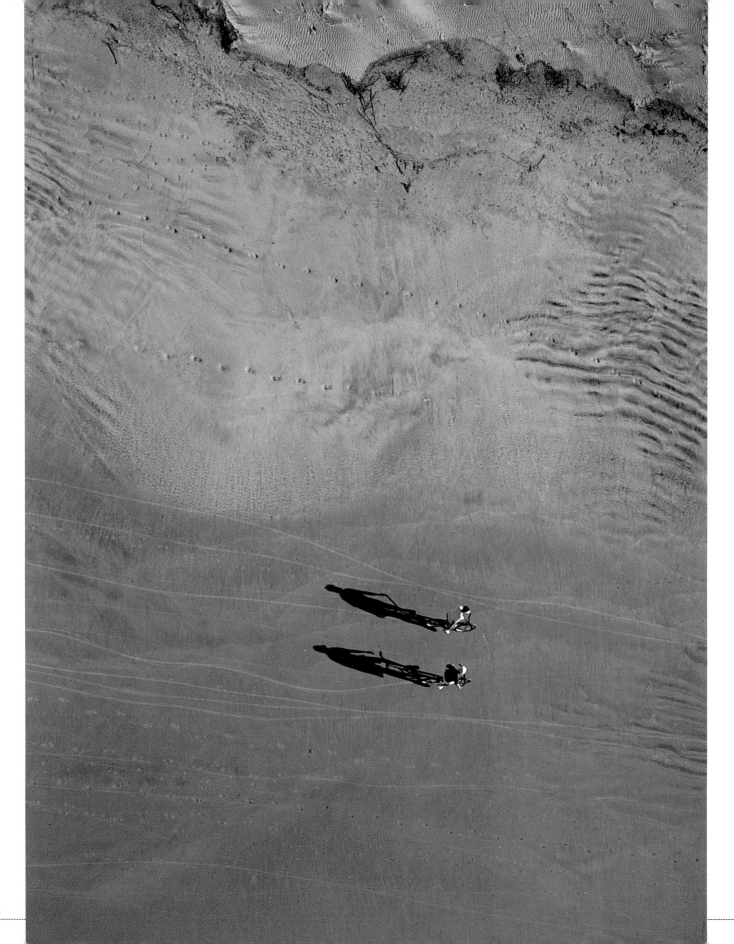

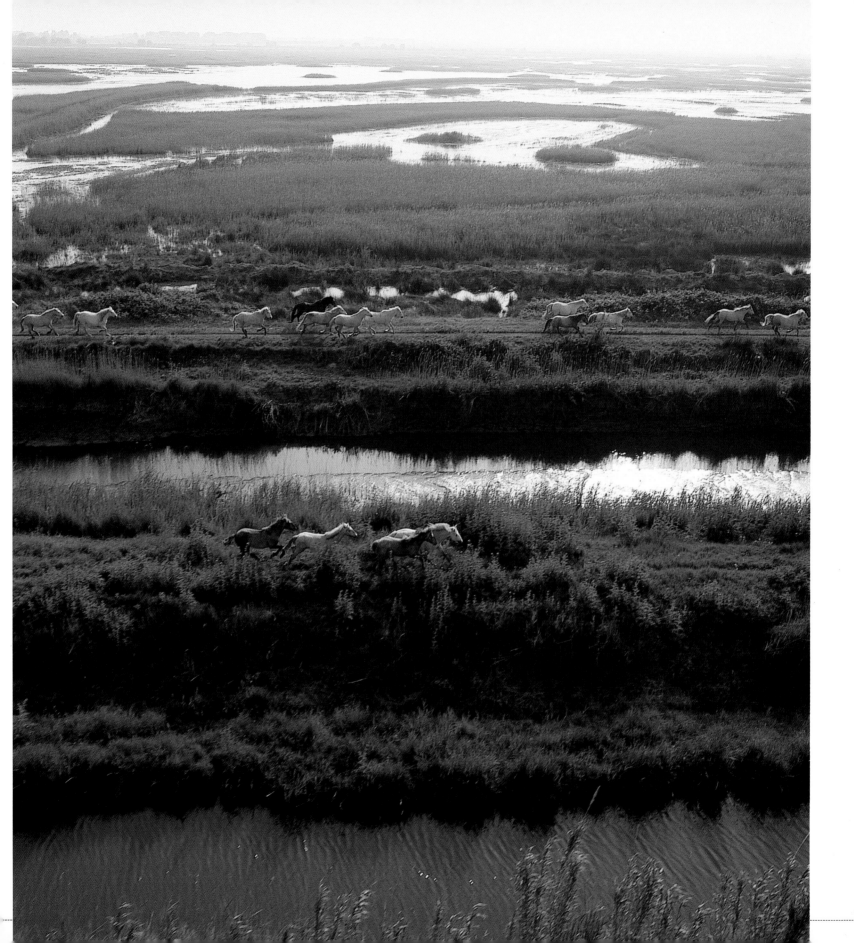

↑ **Wild horses in the Camargue, France**
The Rhône delta was responsible for the formation of the 350,000 acres of wetlands, pastures, dunes and salt flats that make up the Camargue, a UNESCO world heritage site. It is an amazing landscape. I saw these wild horses from 2,000ft up and dropped right down to make one quick pass to capture a dramatic image of them in the surrounding landscape.

↰ **Westbury White Horse, England**
While I now have a Global Positioning Satellite receiver (GPS) in the helicopter and a handheld one to download information to my computer, when I started shooting about 12 years ago, they were a little beyond my budget, so I relied upon just a series of aviation charts. I produced a book of prehistoric sites in Britain. Some were a little difficult to find. I had been supplied maps and details of what to look for. I flew down to Cornwall to photograph Men-an-Tol. It was not surprising that it took me a while to find it. I knew that we were overhead but could see nothing that resembled a burial chamber or stone circle. An hour later we finally found it: a stone the size of a fridge with a hole in it; easy to locate on the ground but more than a bit difficult from 1,500ft.

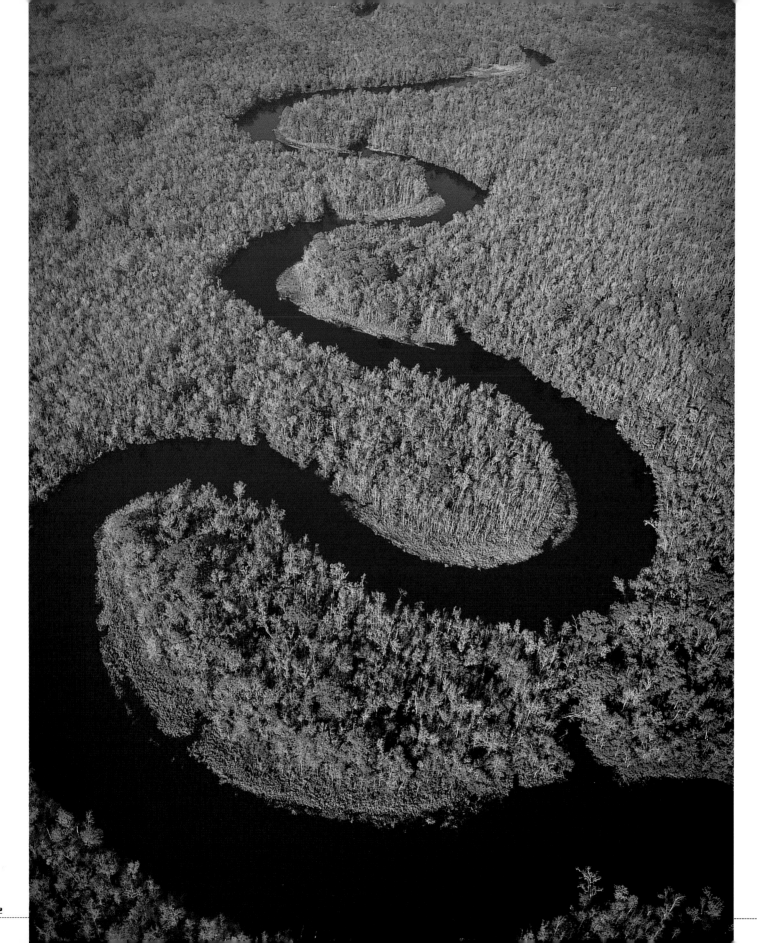

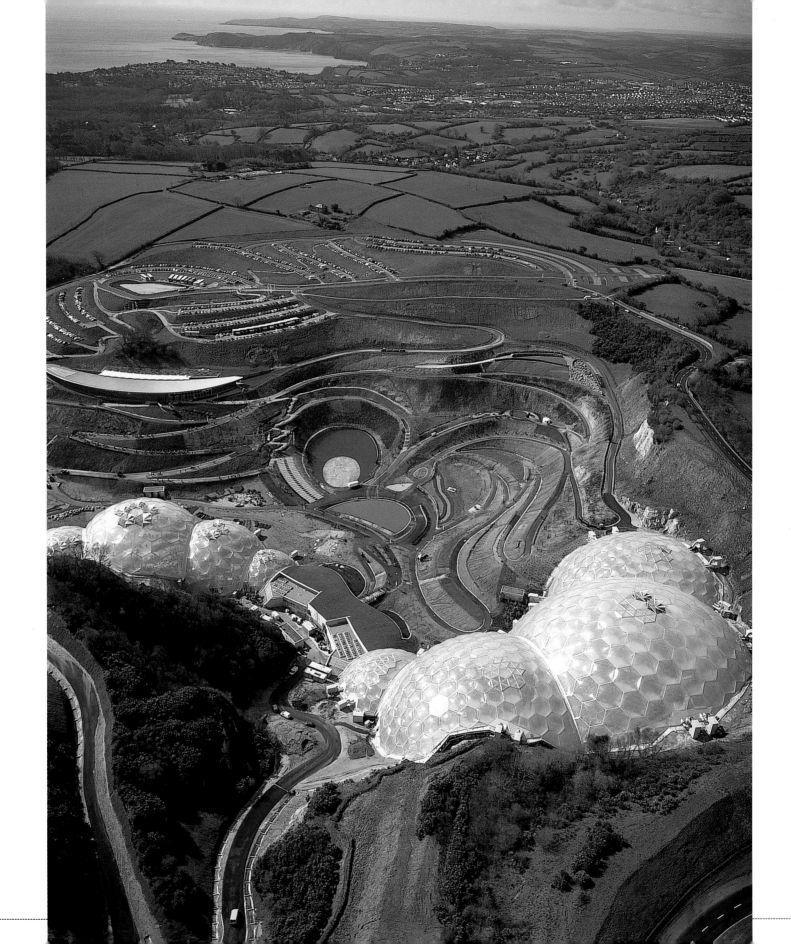

↑ South Carolina, USA *(previous page)*
Shortly after taking this image we almost crashed. I say we – it was really the fault of another aircraft, but the end result would have been the same. We were flying back to Beaufort 'International' which was in fact a tiny airport mostly used by local flying schools and the odd private pilot. We had been flying in and out daily for around three weeks and as usual were talking to the air-traffic controller at the field. We had around half a mile to run so he gave us clearance and instructed a departing Cessna 150 to make way. The instructor in the Cessna later described to me how he had seen a four-seater light aircraft fly straight across the path just out of our field of view and head straight for us. He had tried to contact the aircraft but the pilot was not on the local bandwidth. Too late for us to do anything about it the aircraft crossed right through our intended flight path about 50ft in front of us.
To cross over an active field in this way the pilot should have communicated beforehand, and would have been given instructions to climb to 2,000ft to ensure safe clearance of other aircraft. I remember thinking we were certainly too close as I could see the color of his hair.

↑ Domes of the Eden Project, Cornwall, England *(previous page)*
From any angle this is a strange and unexpected piece of architecture to find in the landscape. And, even from above, it is difficult to appreciate the scale of it, and to imagine a time when it will seem a 'natural' element in its surroundings, despite the fact it actually houses plants.

↱ Water treatment plant, Georgia, USA
This is a pretty mundane-looking treatment plant from the ground, purifying water from the surrounding city. From the air, however, it creates a really graphic series of patterns. I've also been told that, among other things, the image resembles eggs frying in a pan.

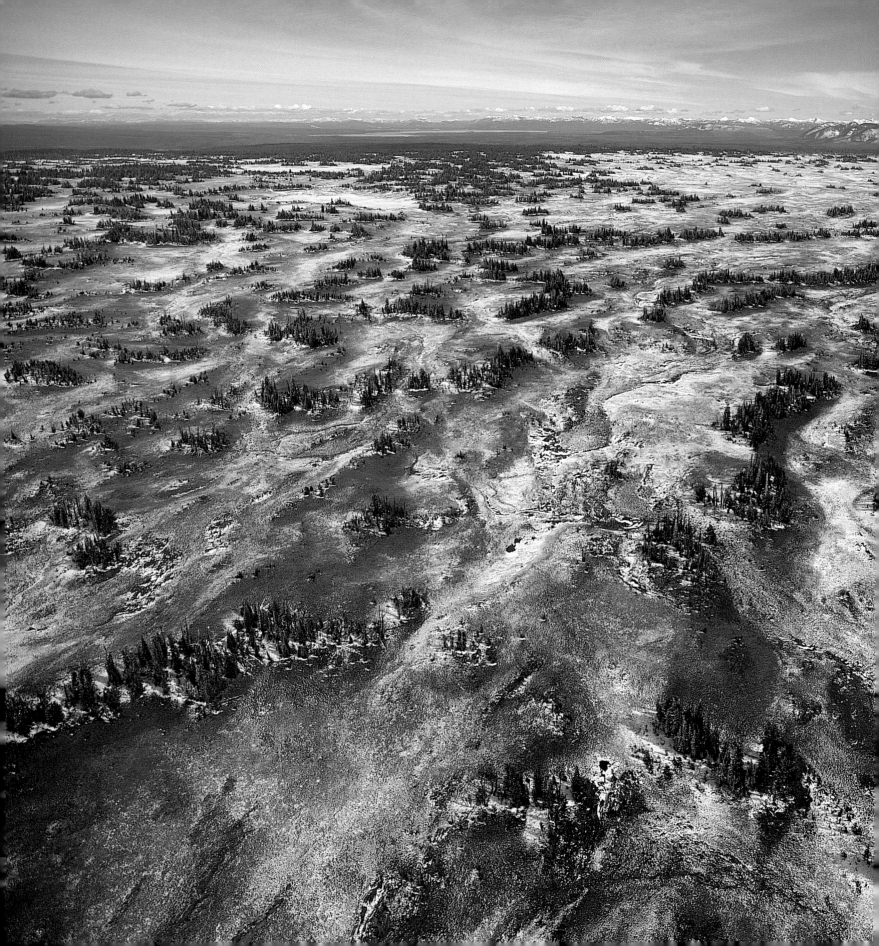

← **Pitchstone Plateau, Yellowstone Park, USA**
At certain times of the year, Pitchstone Plateau forms a stunning, barren landscape. At only 80,000 years old, geologically it represents a 'new' expanse of lava. Rain and snow percolate quickly into the ground here so there are very few streams, and as you can see, trees only grow along the ridges. It was amazingly cold when I flew here, and I was glad I was wearing an all-in-one ski suit. The pilot I flew with was something of a local hero, having flown in terrible snow storms in search-and-rescue missions around the Teton Mountains. It isn't possible for most pilots to keep their helicopters in their back garden, but this guy lived on the outskirts of the National Park and was able to hangar his Longranger helicopter just across from his house.

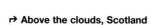

Above the clouds, Scotland

*I had been flying around Scotland in an R44.
We had stayed a few nights with some friends of
the pilot who owned some fantastic cottages on
the Knoydart Peninsula overlooking the Isle of
Skye. The cottages were so remote there was a
half-hour walk to where they parked their car,
so they travelled mostly by boat. We parked the
helicopter right on their front lawn, which was
only 10ft from the sea. We planned an early
morning sortie up the coast to photograph
some of the Western Isles, but as we were low
on fuel we first needed to make a quick stop.
The closest place to refuel was Oban airport,
about 40 miles south. We set off in great
sunshine with not a cloud in the sky, but as can
often happen in the hills, after approximately ten
minutes of flying we came across banks of low-
lying cloud in the valleys. The further we went,
the thicker it became, and a quick call to Oban
and air traffic told us if we got there quickly we
could just make it down in a gap in the clouds
overhead. By the time we were there the gap
had closed. The airfield was right beneath us but
there was no way of going down through the
cloud in a single-engined machine using VFR
(Visual Flight Rules). In the end we managed to
fly slowly down the side of a mountain and get
underneath the cloud base, but not before I'd
had visions of us sitting on top of one of the hills
like angels, waiting for the clouds to disperse.*

→ Miami Beach, Florida, USA

Beaches sell well in the editorial and advertising markets, so this was a speculative photograph I took for stock while I was travelling on a three-month sabbatical.

I wanted to look up along the beach and capture the lines of sunloungers, so flew in a R22 helicopter and used a telephoto lens from a height of 600ft. I decided it would be too difficult to take any medium-format kit with me, so in Miami I called up a pro camera store and hired a Pentax 645 and a few lenses. This camera is powered by six AA batteries and, having had them fail on me before, I double-checked that the assistant had loaded up a new set. He confirmed that he had. Half-an-hour out from the airport and, of course, the batteries gave up! The assistant later confessed that he hadn't and waived the rental fee. Luckily for me there was a small shop on the airfield that sold me some new ones, but with hindsight, the lesson is that I should have taken a spare pack with me as I always do back home.

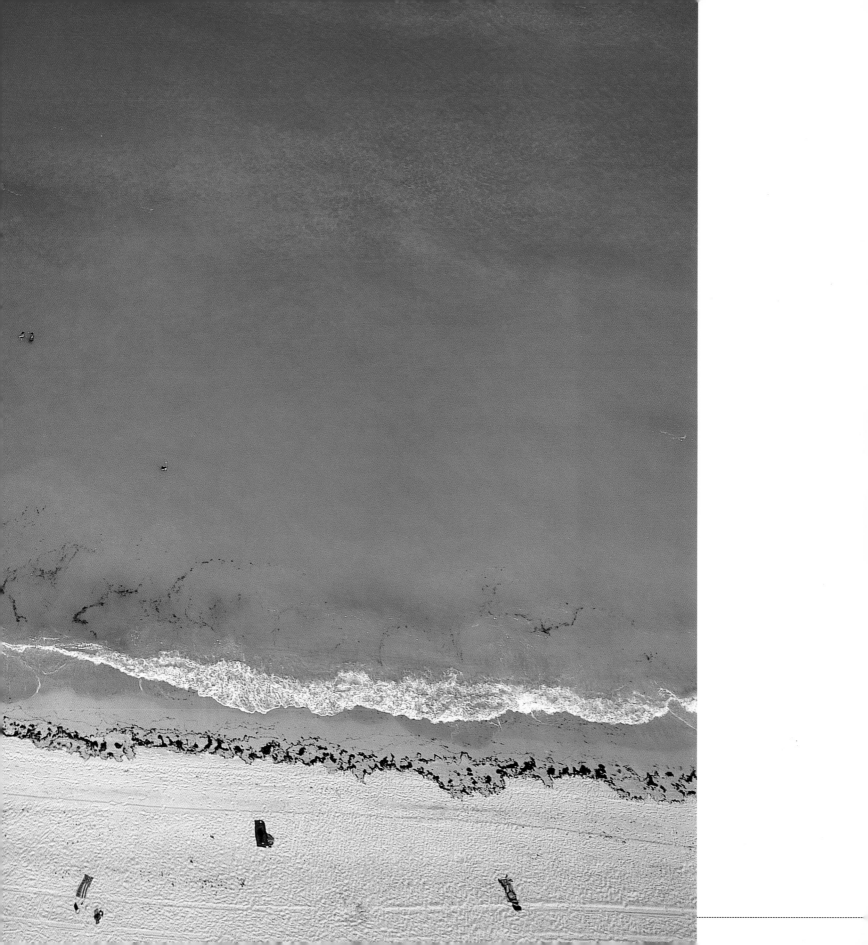

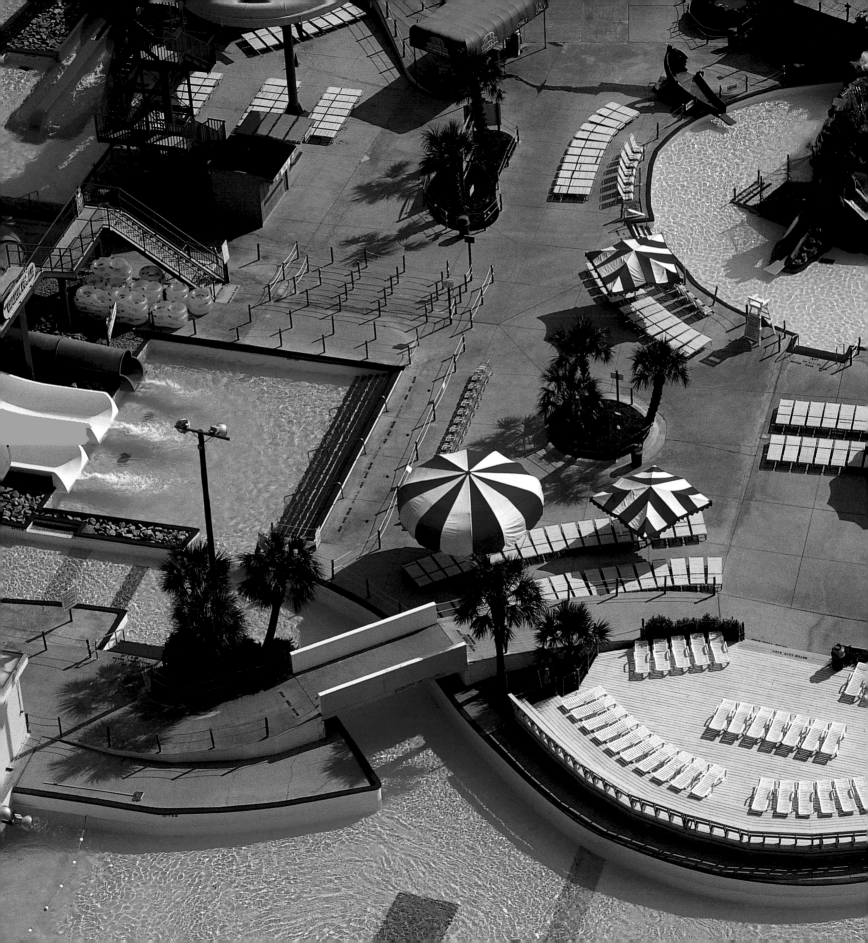

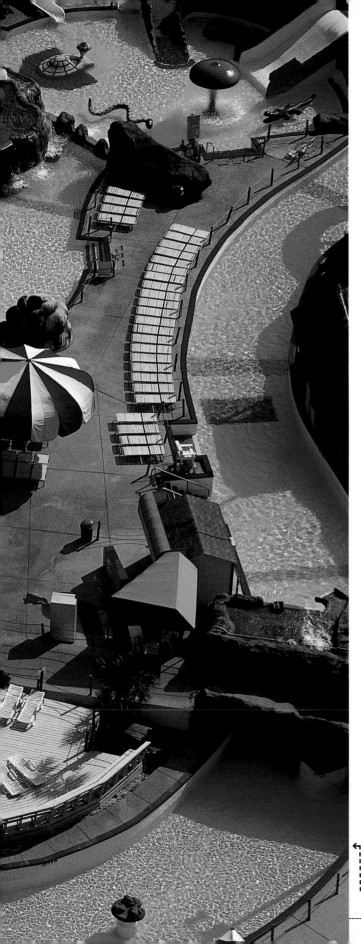

← **Waterpark**
I like the kitsch feel of this image. From above,
the miniature effect makes it look like somewhere
Barbie might go on vacation.

← **Cross-section of streets in Provence, France**
The really attractive part of this image, apart from the star-shaped composition, is the lovely muted oranges and reds of the terracotta roof tiles that are typical of Provence.

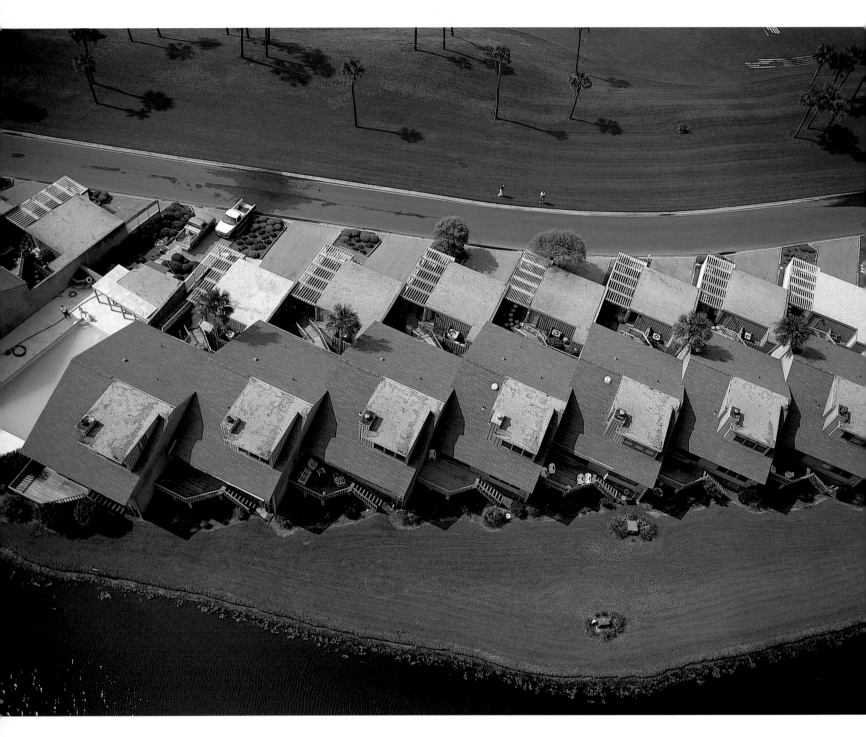

↑ Row of modern housing, South Carolina, USA

In South Carolina the division between poor and rich is nowhere more apparent than in the housing. Modern housing developments and gated communities such as Sun City have sprung up in close proximity to golf courses, serving to underscore the affluence of those who live here. My one regret is that I was unable to take a photograph that demonstrated the discrepancy.

From the ground, these shacks are often painted vibrant reds and blues but from the air I found that the dull tin roofs were hidden in tightly wooded areas. It goes to show that there are some limits to aerial photography, and I was unable to highlight the relative 'invisibility' of this community.

→ M16 headquarters on the River Thames, London, England

From powerless to powerful. I'm told the architecture is designed to look like fortifica give the impression of impenetrable defence to me, it also looks a bit like some sort of elaborate wedding cake.*

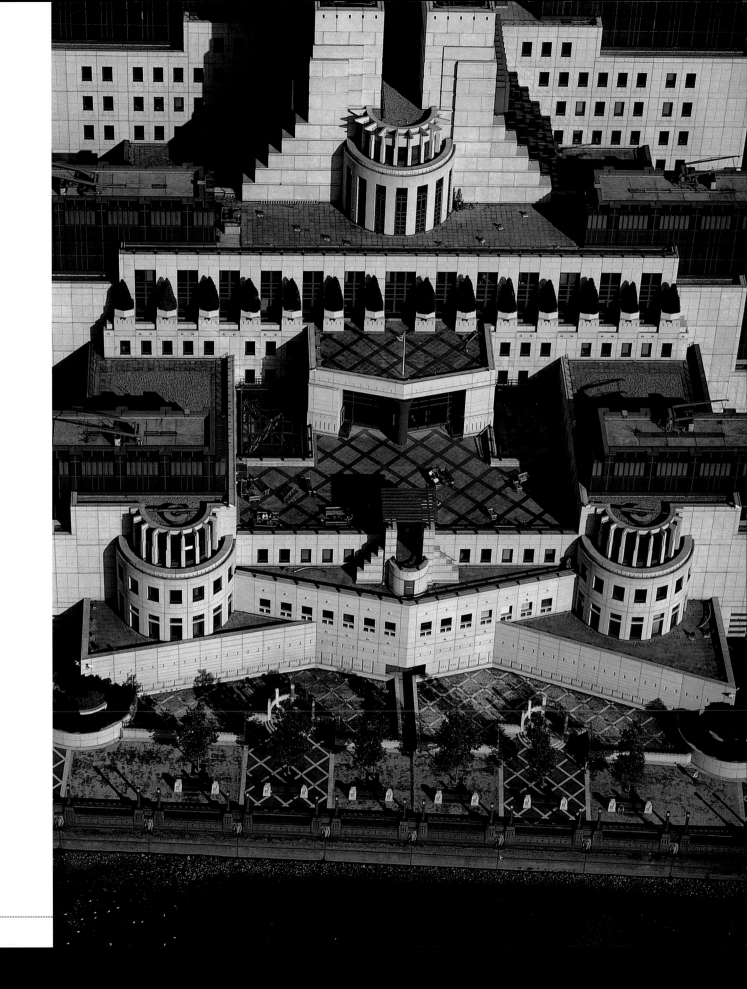

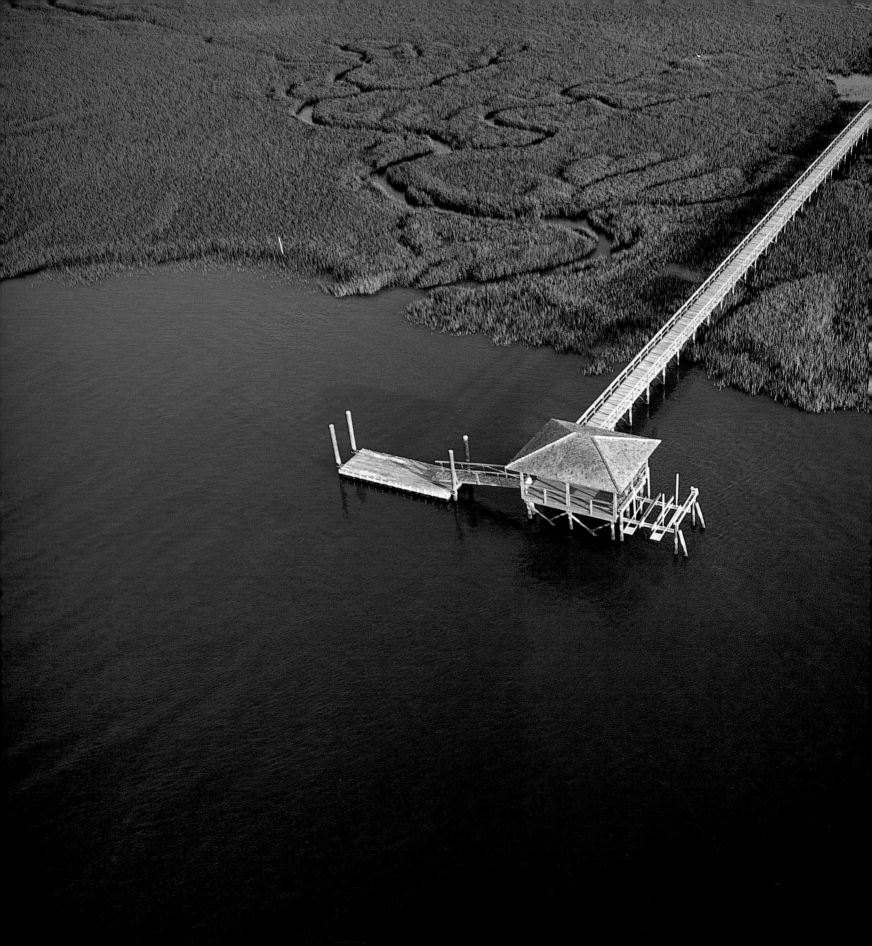

↰ **Boathouse in swamp country, USA**
*What a great boathouse. This image is really
resonant of the deep south for me.*

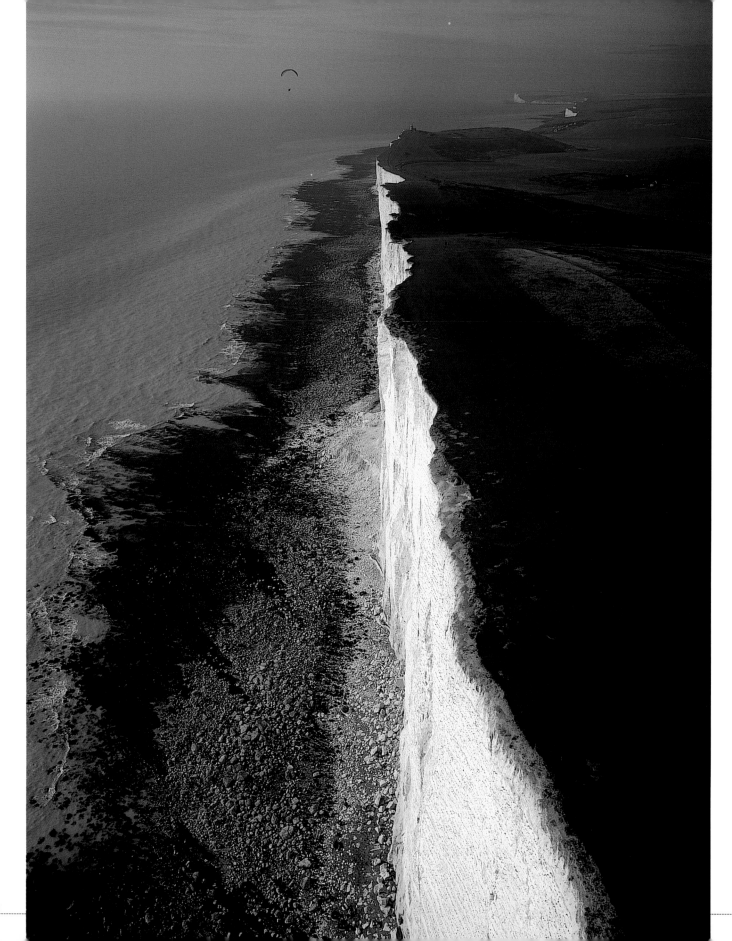

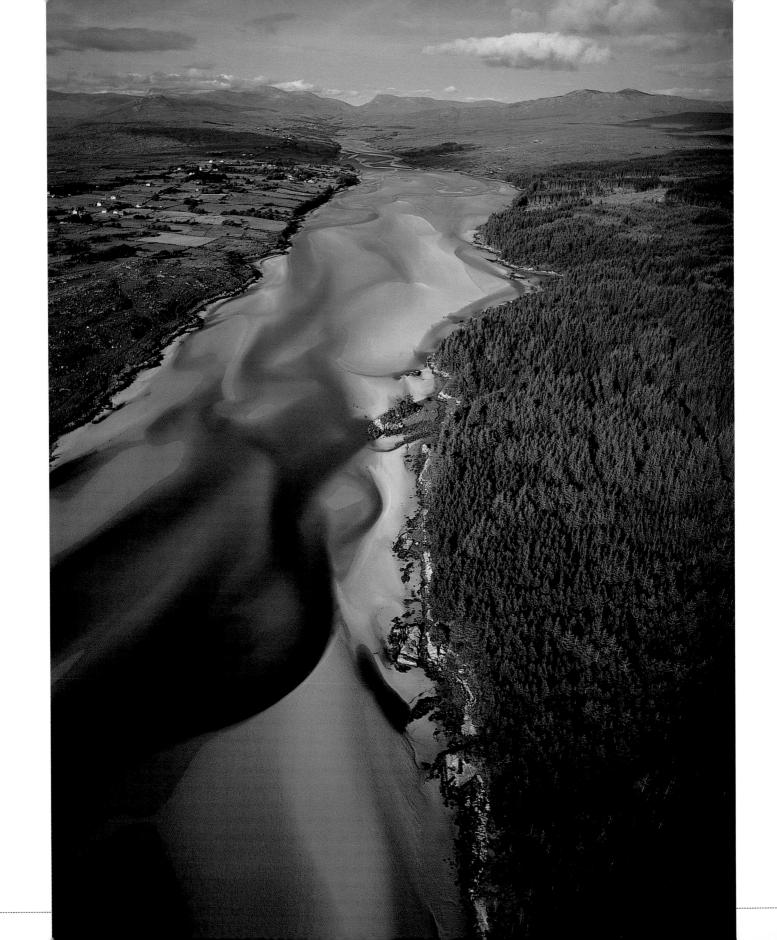

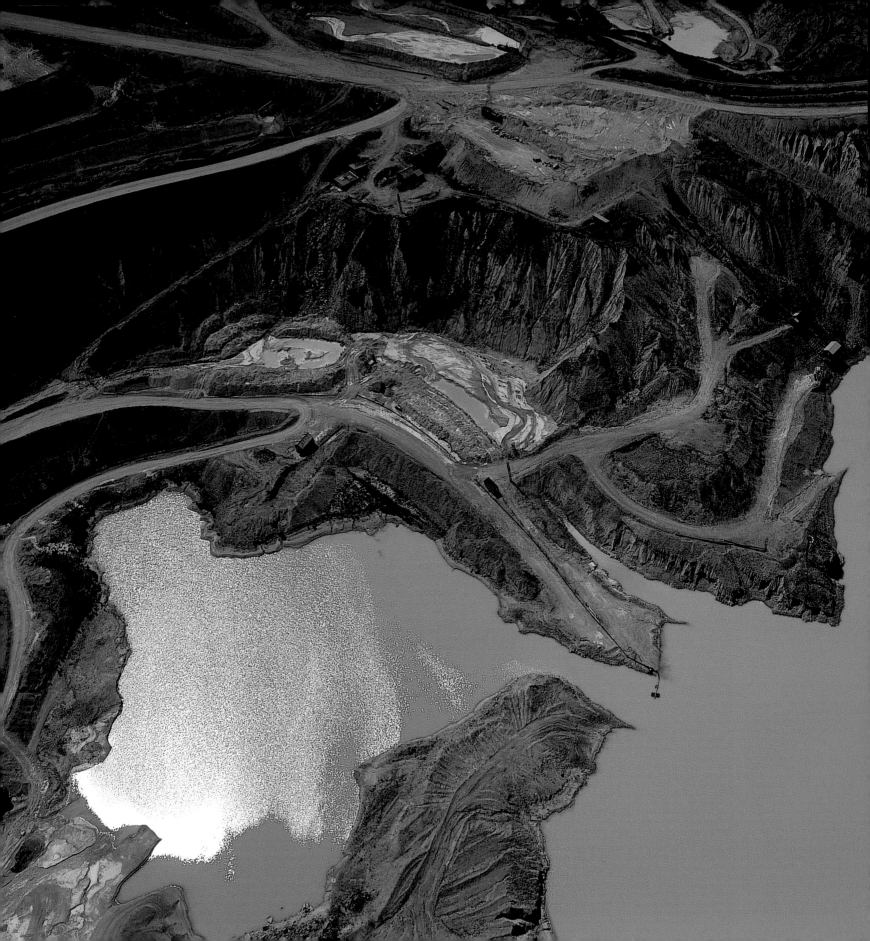

↑ **White cliffs, south coast of England** (previous page)
This stretch of coastline is famous for its chalk cliffs. This shot was taken at an oblique angle and forms one of a series of images that I took of this view. I like the way the ragged edge of the cliff line looks like a giant tear down the length of the image.

↑ **Gweebarra River, Ireland** (previous page)
This is an incredible location in County Donegal and is one of those places where I wish I'd had the opportunity to land, and to spend an hour or two walking around. I am told it's just as beautiful from the ground as it is from the air.

← **Claypit mines**
I'm always staggered by the unexpected and, I suppose, ironic beauty of water in a place like this. Blue, sparkling, it is a foil for the ugliness of the carved out landscape of the clay mines.

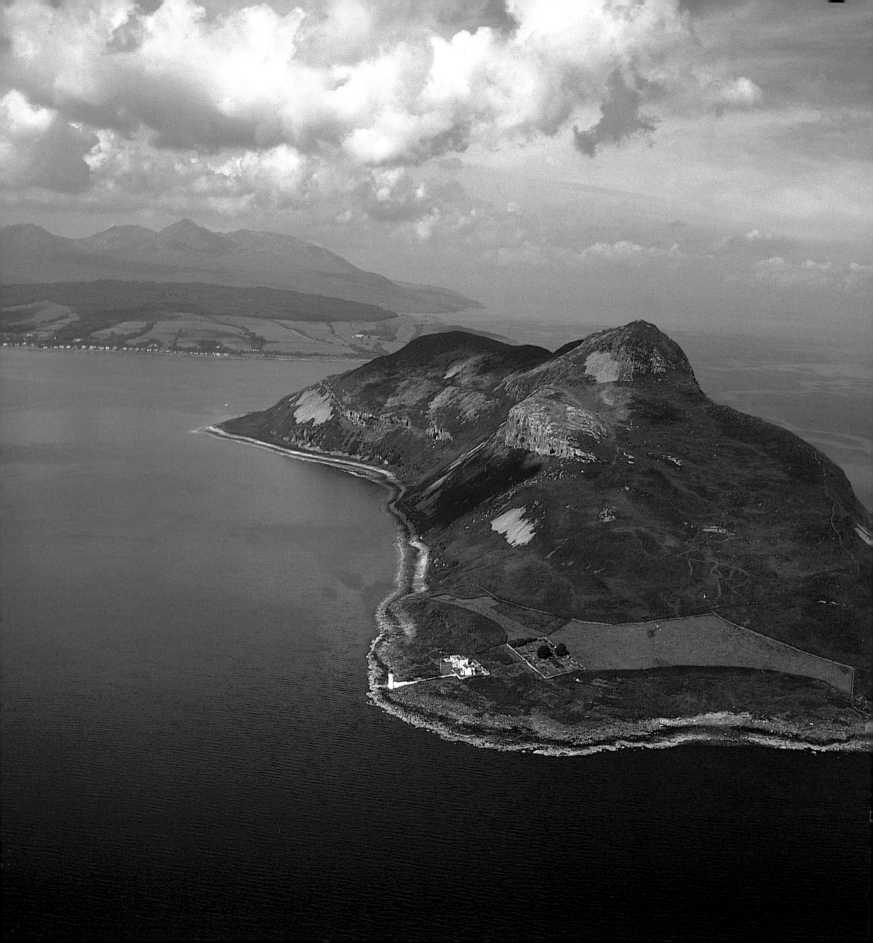

Holy Isle off the Isle of Arran, Scotland

I have worked on two books on Scotland. This image is from the second, but it was while shooting the first that I learned a valuable, if rather obvious lesson. We were flying from the mainland across to a cottage we had booked on the Isle of Arran, just off the west coast of Scotland. We aimed to stay there for a week using it as a base to photograph the Western Isles. We refuelled at Glasgow airport and popped into the city to pick up some supplies for the week. It was raining by the time we were ready to depart, and since I figured there would be little photographic opportunity on the short flight, and because we now had a little extra baggage, we carefully stowed my cameras in the small compartments under my seats.

A little over halfway through our flight a whale burst through the surface of the water, and then crashed onto its back creating an incredible splash. I wish I could show you a photograph of it, but I can't. Since then, wherever and whenever I'm flying, the camera is with me, ready to catch any such unexpected images.

Image index

p78/9 p80/1 p82 p83 p84 p85 p86

p87 p88 p89 p90 p91 p92/3 p94/5 p96

p97 p98/9 p100/1 p102/3 p104 p105

p106/7 p108/9 p110 p111 p114/5 p116/7 p118/9

p120 p122 p123 p124/5 p126/7 p128 p129 p130/1

p132 p133 p134/5 p136/7 p138/9 p140/1 p142/3

p144/5 p146 p147 p148/9 p150 p151 p152/3 p154

Acknowledgments

I'd firstly like to thank my wife Adele, for all her help with the ideas and text for this book. At RotoVision, Kylie and Luke for all their help with the layouts and production. Lastly, Ian Evans, who I have been flying with for the last few years and without whom I would not have been able to take half of these images.

Jason Hawkes, 2003

"YOU ARE NOT ON THE GROUND, YOU ARE 3,000FT ABOVE IT, STRAPPED INTO A HARNESS THAT FITS MORE THAN SNUGLY AROUND YOUR LEGS AND WAIST, AND IS TIGHTLY BOLTED TO THE UNDERSEATING OF A LONGRANGER HELICOPTER. THE DOOR TO YOUR LEFT, ABOUT TWICE THE SIZE YOU WOULD FIND ON THE AVERAGE CAR, HAS BEEN TAKEN OFF SO THAT YOU CAN LEAN OUT AS FAR AS NECESSARY."

"THE AIRBORNE MAN SEES THINGS THAT ARE HARD FOR THE PEOPLE ON THE GROUND TO COMPREHEND. HE BECOMES FAMILIAR WITH THESE THINGS. BECAUSE YOU'RE A LAYMAN, IF YOU HAVE AN INTENSE INTEREST IN THE VISION ASPECT OF THIS, YOU ACCUMULATE KNOWLEDGE THAT BEGINS TO FIT TOGETHER IN A BIGGER PATTERN. I HAVE A PLATFORM FOR OBSERVATION."